Imprint

Editor:	Karin Mahle
Editorial coordination:	Nicole Haeusermann
Photos (location):	courtesy AXE (AXE), Benny Chan (ChoSun Galbee 44, 46), Mark Luthringer (ChoSun Galbee 45, 48), courtesy Cinch (Cinch & food), Benny Chan (Falcon), Jim Walker (Minibar 104), Fred Turko (Minibar food), courtesy Norman's (Norman's), courtesy Table 8 (Table 8), courtesy Tantra (Tantra food). All other photos by Martin Nicholas Kunz.
Introduction:	Karin Mahle
Layout & Pre-press:	Thomas Hausberg
Imaging:	Florian Höch
Translations:	Ade Team, Margarita Celdràn-Kuhl / Dr. Miguel Carazo (Spanish), Dr. Andrea Adelung / Robert Kaplan (English), Birgit Chengab / Ludovic Allain (French), Jacqueline Rizzo (Italian) Nina Hausberg (German / recipes)

Published by teNeues Publishing Group

teNeues Publishing Company
16 West 22nd Street, New York, NY 10010, USA
Tel.: 001-212-627-9090, Fax: 001-212-627-9511

teNeues Book Division
Kaistraße 18, 40221 Düsseldorf, Germany
Tel.: 0049-(0)211-994597-0, Fax: 0049-(0)211-994597-40

teNeues Publishing UK Ltd.
P.O. Box 402, West Byfleet, KT14 7ZF, Great Britain
Tel.: 0044-1932-403509, Fax: 0044-1932-403514

teNeues France S.A.R.L.
4, rue de Valence, 75005 Paris, France
Tel.: 0033-1-55 76 62 05, Fax: 0033-1-55 76 64 19

teNeues Iberica S.L.
Pso. Juan de la Encina 2–48, Urb. Club de Campo
28700 S.S.R.R. Madrid, Spain
Tel./Fax: 0034-91-65 95 876

www.teneues.com

ISBN-10:	3-8238-4589-6
ISBN-13:	978-3-8238-4589-8

© 2005 teNeues Verlag GmbH + Co. KG, Kempen

Printed in Germany

Picture and text rights reserved for all countries.
No part of this publication may be reproduced in any manner whatsoever.

All rights reserved.

While we strive for utmost precision in every detail, we cannot be held responsible for any inaccuracies, neither for any subsequent loss or damage arising.

Bibliographic information published by Die Deutsche Bibliothek. Die Deutsche Bibliothek lists this publication in the Deutsche Nationalbibliografie; detailed bibliographic data is available in the Internet at http://dnb.ddb.de.

Contents	Page

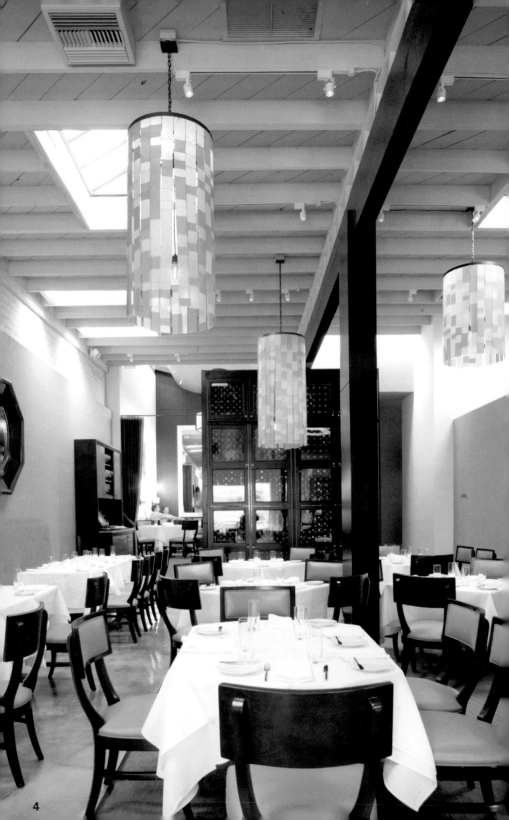

Introduction

In recent years, the restaurant scene in Los Angeles has experienced a great upheaval. The borders between reasonably priced and expensive, hip and established are becoming increasingly blurred. Even a noodle soup shop advances into a cult site if designed by the right architect—for example the Pho Café by Escher Gunewardena. Or, in order to reach an appropriate audience, a gourmet temple such as the Bastide equally awaits with the interior made by the hand of the world famous interior architect Andrée Putman. With that, the new restaurant culture in Los Angeles follows suit with its movie-making tradition once again: even in former times, the staging of the dining rooms was considered a domain of the set designer who wanted to provide the producer and the stars with the right setting after a film premiere. The scenery there was supposed to be at least as magnificent as the film. It's a matter of the second—the social—appearance of the evening.

While going out between Hollywood, Venice, Santa Monica, Beverly Hills, or downtown, there are three noteworthy matters to observe: the public goes to dinner early—starting from 6:00 pm—so that they look fresh on the set the next morning. Smoking is prohibited, less alcohol is consumed. The menus correspond to an Atkins diet; vegetarians will have a tough time. On top of that: the waiters (in reality, they are all actors) immediately dub someone a nobody if they don't make at least two changes in a dish. As if the legendary film scene in "When Harry Met Sally" is a creed: "One mixed salad please, but don't mix it and without salad and above all, no sauce on it...". At the same time, one is astounded if one finds oneself as one of the few guests who also touch their food or—very wrong—eat it all up. Here, one orders a lot and eats little. The kitchen is absolutely world class, the chefs arise to top form—but the pure culinary delights are minor considerations. Seeing and being seen are the top priorities. In this point the film metropolis cannot be beaten.

So, let yourself be abducted to a culinary and optically opulent tour of the coolest sets on the following pages, into a mixture of reasonably priced and expensive, minimalist and pompous, but above all to the places where you can most probably experience the stars up close.

Karin Mahle

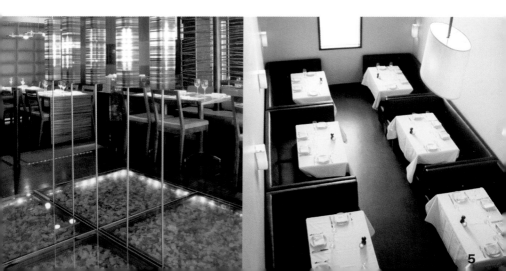

Einleitung

Die Restaurantszene in Los Angeles hat in den letzten Jahren einen großen Umschwung erlebt. Die Grenzen zwischen preiswert und teuer, hip und etabliert verwischen dabei zunehmend. Auch ein Nudelsuppenladen avanciert zur Kultstätte, wenn ihn der richtige Architekt entworfen hat, wie etwa das Pho Café von Escher Gunewardena. Oder ein Gourmettempel wie das Bastide wartet gleich mit Interieur aus der Hand der weltbekannten Innenarchitektin Andrée Putman auf, um das passende Publikum zu erreichen. Damit schließt die neue Restaurantkultur in Los Angeles wieder an ihre cineastische Tradition an: Schon früher galt die Inszenierung der Speiseräume als eine Domäne der Set-Designer, die Produzenten und Stars den richtigen Rahmen nach einer Filmpremiere geben wollten. Da sollte das Dekor mindestens so prächtig wie der Film sein. Geht es doch um den zweiten – den gesellschaftlichen – Auftritt des Abends.

Beim Ausgehen zwischen Hollywood, Venice, Santa Monica, Beverly Hills oder Downtown sind drei Besonderheiten zu beachten: Das Publikum geht früh – ab 18 Uhr – zum Dinner, damit es am nächsten Morgen auf dem Set frisch aussieht. Rauchen ist verboten, Alkohol wird weniger konsumiert. Die Menüs entsprechen der Atkins-Diät, Vegetarier werden sich schwerer tun. Außerdem: die Kellner (sie sind in Wirklichkeit ja alle Schauspieler) werden einen sofort als Nobody abstempeln, wenn man nicht wenigstens zwei Änderungen an einem Gericht vornimmt. Als wäre die legendäre Filmszene aus „Harry und Sally" ein Credo: „Bitte einen gemischten Salat, aber ohne Mischung und ohne Salat und vor allem ohne Soße darauf...". Dabei wird man erstaunt sein, wenn man sich als einer der wenigen Gäste entdeckt, die ihr Essen auch anrühren oder – ganz falsch – komplett verspeisen. Man bestellt hier viel und isst wenig. Die Küche ist durchaus Weltklasse, die Chefs laufen zu Höchstform auf – die reinen Gaumenfreuden sind aber Nebensache. Sehen und gesehen werden stehen im Vordergrund. Hierbei ist die Filmmetropole nicht zu übertreffen.

Also lassen Sie sich auf den nächsten Seiten entführen, zu einem kulinarischen und optisch opulenten Rundgang an die coolsten Sets, in eine Mischung aus preiswert und teuer, minimalistisch und schwülstig, vor allem aber an die Plätze, wo Sie mit hoher Wahrscheinlichkeit Stars aus der Nähe erleben können.

Karin Mahle

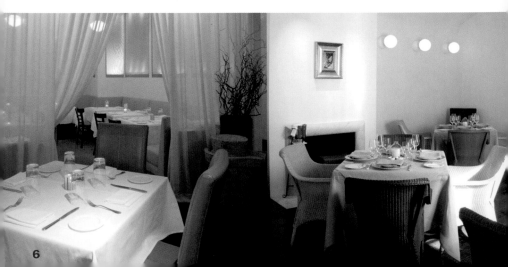

Introduction

Durant les dernières années s'est produit un changement radical de la scène gastronomique à Los Angeles. Les limites entre bon marché et cher, entre hip et établi, se confondent cependant de plus en plus. Même un magasin de soupes aux pâtes est élevé comme lieu culte, si celui-ci a été planifié par le bon architecte, à l'exemple du cas du Pho Café d'Escher Gunewardena. Ou un temple de la gastronomie comme le Bastide attend déjà avec un aménagement intérieur créé de la main d'Andrée Putman, architecte décoratrice de renommée mondiale pour accueillir le public adapté. La nouvelle culture culinaire de Los Angeles renoue ainsi de nouveau avec sa tradition cinéaste : Autrefois déjà, la mise en scène des salles de restaurant était comprise comme un domaine des set designers, qui voulaient donner aux producteurs et aux stars le bon cadre après une première de film. Le décor devait y être au moins aussi fastueux que le film. Puisqu'il s'agit de la deuxième entrée en scène de la soirée, celle en société.

Lors des sorties entre Hollywood, Venice, Santa Monica, Beverly Hills ou Downtown il convient de respecter trois particularités : le public va dîner relativement tôt – à partir de 18.00 heures –, afin que tout le monde ait l'air frais le matin suivant. Il est interdit de fumer, on consomme peu d'alcool. Les menus correspondent au régime Atkins, et donneront du fil à retordre aux végétariens. De plus : les serveurs (qui sont en réalité tous acteurs) classent immédiatement quelqu'un dans la catégorie des « nobody », si celui-ci n'a pas effectué au moins deux modifications à un plat. Comme si la scène légendaire du film « Quand Harry rencontre Sally » était un credo : « Veuillez nous apporter une salade mixte, mais sans mélange, sans salade et surtout sans sauce dessus… ». On sera alors étonné de découvrir qu'on est l'un des seuls invités à toucher leur repas ou, erreur complète, à le manger complètement. Ici, on commande beaucoup et on mange peu. La cuisine est sûrement de classe mondiale, les chefs s'attroupent en pleine forme – mais le pur plaisir du palais n'est pas la chose la plus importante. Le fait de voir et d'être vu sont mis au premier plan. Et la métropole du film est inégalée en la matière.

Laissez vous alors guider dans les pages suivantes dans une visite culinaire et opulente d'un point de vue optique dans les cercles les plus cools, dans un mélange de prix bon marché et chers, minimaliste et exubérant, et surtout aux endroits où vous pourrez vivre les stars de près en toute vraisemblance.

Karin Mahle

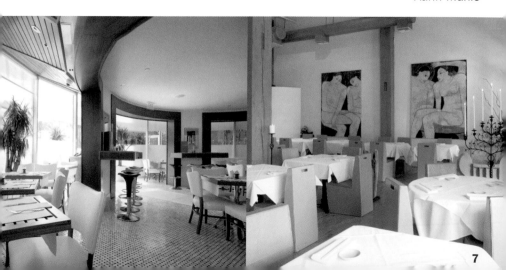

Introducción

La escena de restaurantes de Los Angeles ha experimentado un gran cambio en los últimos años. Los límites entre caro y económico, moderno y tradicional van difuminándose cada día más. Hoy, una tienda de sopas de fideos puede llegar a convertirse en un lugar de culto, si la ha diseñado el arquitecto adecuado, como es el caso del Pho Café de Escher Gunewardena. También se da el caso de un templo del gourmet como el Bastide que luce un interior creado por la interiorista de renombre mundial Andrée Putman, para atraer al público deseado. De esta forma, la nueva cultura de los restaurantes de Los Angeles vuelve a retomar su tradición cineasta: Ya en épocas anteriores la decoración de los comedores era el dominio de los diseñadores de sets, cuyo propósito era crear el marco apropiado para los productores y las estrellas de cine después del estreno de una película. El objetivo era crear una decoración tanto o más lujosa que la de la película, ya que se trataba ni más ni menos que de la segunda salida a escena de esa noche, esto es, la presentación en sociedad.

Al salir en las zonas de Hollywood, Venice, Santa Monica, Beverly Hills y Downtown hay que tener en cuenta tres particularidades: El público cena pronto, a partir de las 18.00 horas, para que a la mañana siguiente presente un aspecto despejado en el set. Está prohibido fumar y se consume menos alcohol. Los menús corresponden a la dieta Atkins, y los vegetarianos tendrán algún que otro problema. Además, los camareros (que en realidad son todos actores) enseguida le considerarán a uno un don nadie si no se solicitan al menos dos cambios en un plato. Como si la legendaria escena de la película "Cuando Harry encontró a Sally" fuera un credo: "Por favor, una ensalada mixta, pero sin mezclar y sobre todo sin salsa...". No se sorprenda, si resulta ser usted uno de los pocos huéspedes que ha probado el plato que le han servido o –lo que sería completamente equivocado– se lo hubiera comido entero.

Aquí se pide mucho y se come poco. La cocina realmente es de categoría internacional, los chefs crean exquisiteces sin igual, pero el disfrutar de la comida es algo secundario. Lo que aquí cuenta es ver y ser visto. En este aspecto, esta metrópoli es insuperable.

Ahora ya sólo tiene que dejarse seducir por las siguientes páginas, que le acompañarán en un viaje culinario y de una gran opulencia visual a los sets que están causando mayor furor, donde encontrará una mezcla de caro y barato, minimalista y pomposo, pero sobre todo lugares, en los que con seguridad verá a las estrellas de cine actuar de cerca.

Karin Mahle

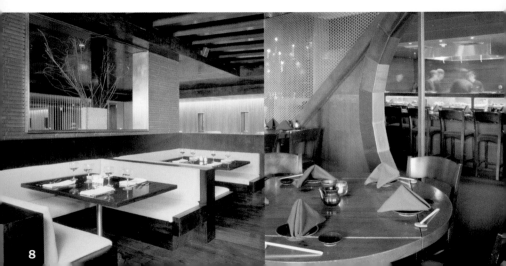

Introduzione

Lo scenario dei ristoranti a Los Angeles durante questi ultimi anni ha sperimenta-to un grande cambiamento. I confini tra l'economico ed il costoso, tra l'hip ed il tradizionale si confondono sempre di più. Anche la piccola bottega della zuppa può diventare locale di moda se è stata disegnata dall'architetto giusto come ad esempio il Pho Café di Escher Gunewardena. Oppure un tempio del buongustaio come il Bastide si presenta addirittura con arredi creati da Andrée Putman, archi-tetta di fama mondiale, per poter raggiungere il pubblico adatto. Con ciò la nuova cultura di ristoranti a Los Angeles si ricollega alla sua tradizione del cinema: già tempo fa la messa in scena delle sale di pranzo era considerata di dominio dei di-segnatori dei set che volevano dare la giusta cornice ai produttori del cinema ed agli star, dopo la celebrazione delle prime. Per questo la decorazione doveva es-sere almeno sontuosa come il film che era stato presentato. In fondo si tratta della seconda entrata in scena della serata – quella sociale.
Quando si esce la sera tra Hollywood, Venice, Santa Monica, Beverly Hills oppure Downtown, bisogna tenere presenti tre particolarità: il pubblico esce presto – a partire dalle ore 18 – per andare a cena, in modo da essere riposati la mattina dopo sul set. Vige il divieto di fumo, si consuma meno alcol. I menu corrispondo-no alla dieta Atkins, i vegetariani faranno fatica a trovare i menu adatti per loro. Inoltre: i camerieri (naturalmente in realtà sono tutti attori) ci apporranno subito la marchiatura di essere nessuno, se non si effettuano al meno due modifiche al menu scelto. Come se la leggendaria scena tratta dal film "Harry, ti presento Sally" fosse un'ideologia: "Ci porti un'insalata mista, ma senza mescolanze e sen-za insalata e soprattutto senza condimento…". E con stupore ci si ritrova essere uno dei pochi ospiti i quali toccano la loro pietanza oppure – che errore – finisca-no di mangiarla. Da queste parti si fa una grande ordinazione, ma si mangia po-co. La cucina è assolutamente di classe, i chef si presentano in ottima forma – ciononostante le gioie del palato sono solo secondarie. Quello che conta è vedere ed essere visti. In questo, la metropoli del film è ineguagliabile.
Pertanto lasciatevi portar via dalle prossime pagine, seguendo un giro culinario con ed opulenti panorami, verso i set di moda, in un miscuglio tra l'economico ed il costoso, il minimalistico ed il pomposo, ma soprattutto per trovare quei posti ove con molta probabilità potrete vedere gli star da vicino.

Karin Mahle

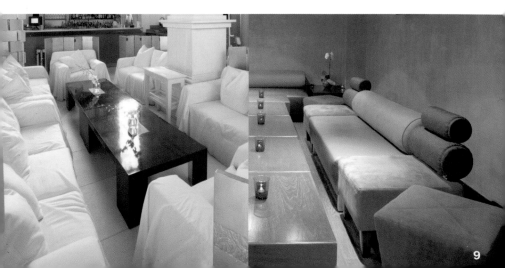

Ago

Chef: Agostino Sciandri

8478 Melrose Ave / La Cienega Blvd | West Hollywood, CA 90069
Phone: +1 323 655 6333
Opening hours: Mon–Fri 12 noon to 2:30 pm, 6 pm to 11:30 pm,
Sat 6 pm to 11:30 pm, Sun 6 pm to 10:30 pm
Average price: $ 38
Cuisine: Italian
Special features: Terrace, bar scene, celeb hangout, valet parking

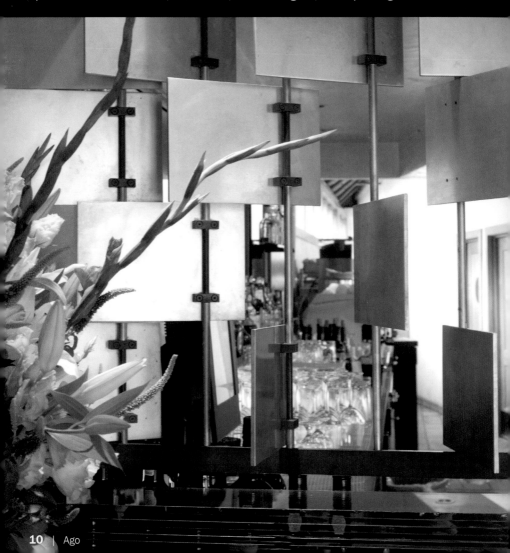

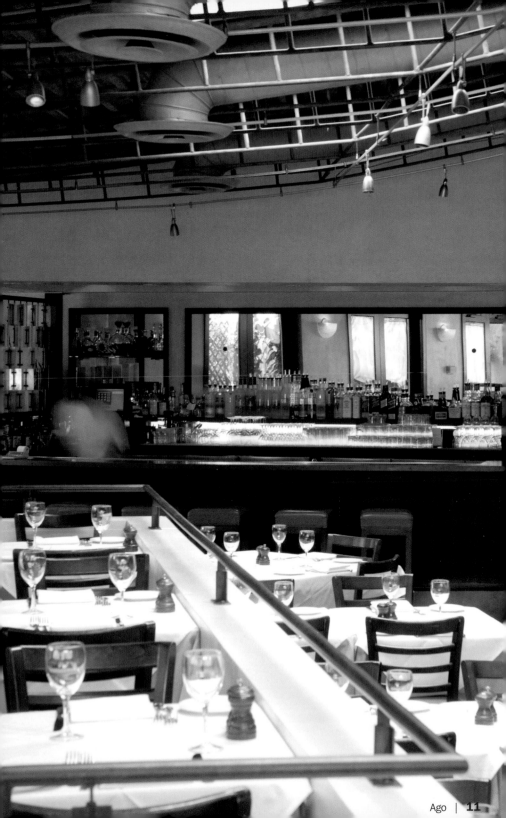

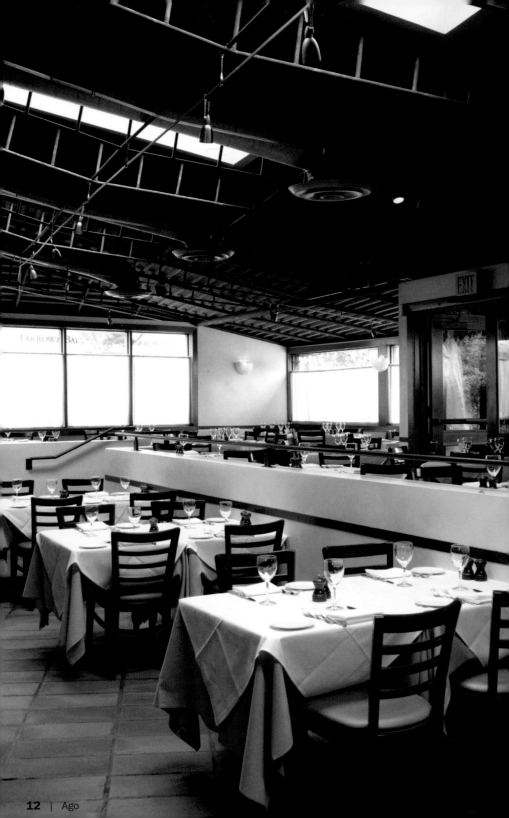

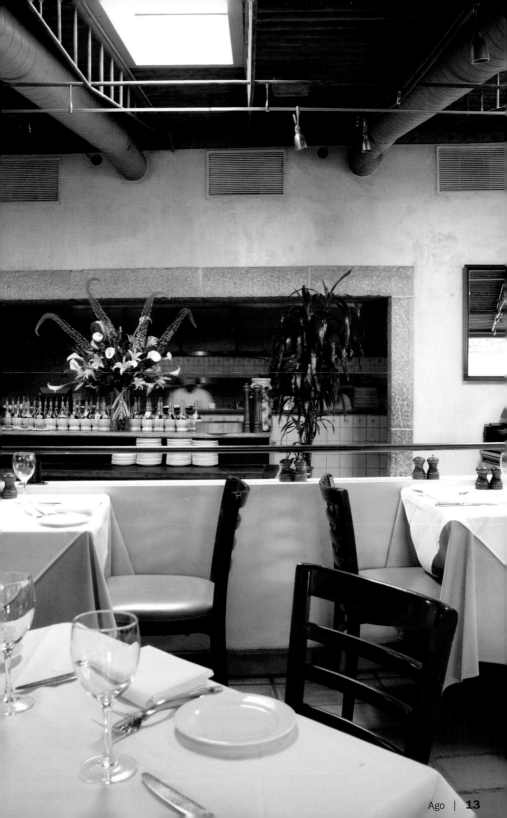

Ammo

Design: Graft Architects, www.graftlab.com
Owner: Benedikt Bohm | Chef: Piero Morovich

1155 N Highland Ave | Los Angeles, CA 90038
Phone: +1 323 871 2666
Opening hours: Mon–Fri 11 am to 3 pm, Mon–Thu 6 pm to 10 pm,
Fri–Sat 6 pm to 11 pm, Sat–Sun 10 am to 3 pm
Average price: $ 25
Cuisine: New American, Californian
Special features: Brunch and lunch spot for creative people

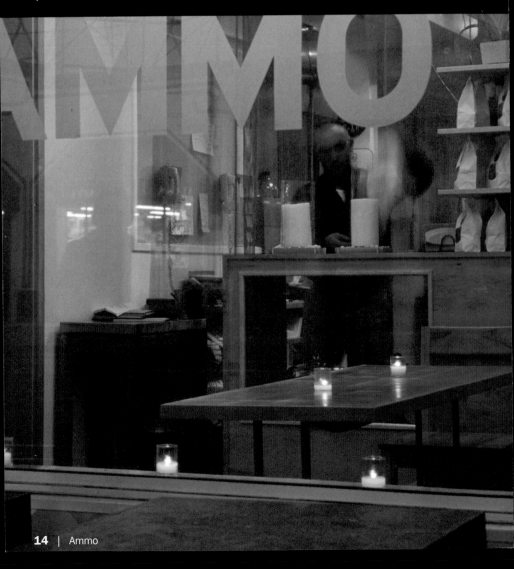

Ammo's
Turkey Meatloaf

Ammo's Truthahnhackbraten

Rôti de viande hachée de dindon d'Ammo

Asado de carne picada de pavo
al estilo Ammo

Polpettone di tacchino all'Ammo

1 tbsp butter
$^3/_4$ cup minced green onions
$^3/_4$ cup minced white onions
$^3/_4$ cup minced carrot
$^3/_4$ cup minced red bell pepper
2 tsp minced garlic
1 tsp salt
1 tsp pepper
$^1/_2$ tsp cayenne pepper
2 eggs
$^1/_2$ cup ketchup
2 lbs lean ground turkey

Combine first six ingredients and sautée until moisture has evaporated and cool.
In large mixing bowl, combine the salt, pepper, cayenne pepper, eggs and ketchup. Blend thoroughly, then add the ground turkey and vegetable mixture and form loaf. Put in greased loaf pan and bake in a preheated 350 °F oven for 45–60 minutes.

Let rest for 30 minutes before serving.

Meatloaf Sauce:
2 tbsp butter
4 shallots minced
1 sprig thyme
$^1/_4$ cup minced red bell peppers
$^1/_2$ cup ketchup
1 tsp pepper
2 tsp minced garlic
2 cup chicken stock
2 tomatoes, peeled and diced

In a heavy pan, melt butter and saute shallots, garlic, red bell peppers, thyme, salt and pepper to taste over medium heat until soft. Add the chicken stock and simmer uncovered, over high heat until reduced by one fourth. Add the tomatoes and ketchup and bring to a slow simmer. Cook covered for 20 minutes. Strain before serving.

1 EL Butter
100 g Frühlingszwiebeln, geschnitten
100 g Zwiebeln, geschnitten
100 g Karotte, geschnitten
100 g rote Paprika, geschnitten
2 TL gehackter Knoblauch
1 TL Salz
1 TL Pfeffer
$^1/_2$ TL Cayennepfeffer
2 Eier
70 g Ketchup
1 kg magerer Truthahn, haschiert

Die ersten sechs Zutaten mischen und in einer Pfanne anschwitzen. Abkühlen.
In einer Schüssel Salz, Pfeffer, Cayennepfeffer, Eier und Ketchup mischen, das Truthahnfleisch und das Gemüse untermischen und einen Laib formen. In eine gefettete Form setzen und bei 180 °C ca. 45–60 Minuten backen. Vor dem Servieren 30 Minuten ruhen lassen.

Sauce zum Hackbraten:
2 EL Butter
4 gewürfelte Schalotten
1 Zweig Thymian
50 g gewürfelte rote Paprika
70 g Ketchup
1 TL Pfeffer
2 TL gehackter Knoblauch
500 ml Geflügelbrühe
2 Tomaten, gehäutet und gewürfelt

In einer Pfanne Butter, Schalotten, Knoblauch, Paprika, Thymian, Salz und Pfeffer weich dünsten. Die Brühe hinzufügen und bei großer Hitze um ein Viertel einreduzieren lassen. Den Ketchup und die Tomaten unterrühren und leise weiterköcheln lassen. Zugedeckt 20 Minuten kochen. Dann durch ein Sieb gießen und warmstellen.

1 c. à soupe de beurre
100 g d'oignon printanier, coupés
100 g d'oignon, coupés
100 g de carotte, coupés
100 g de poivron rouge, coupés
2 c. à café d'ail haché
1 c. à café de sel
1 c. à café de poivre
1/2 c. à café de poivre de Cayenne
2 oeufs
70 g de ketchup
1 kg de dindon maigre, haché

Mélanger les six premiers ingrédients et faire blondir dans une poêle. Faire refroidir.
Mélanger dans un saladier le sel, le poivre, le poivre de Cayenne, les oeufs et le ketchup, ajouter la viande de dindon et les légumes puis former un pain. Mettre dans un moule graissé et faire cuire à 180 °C pendant env. 45 à 60 minutes. Laisser reposer 30 minutes avant de servir.

Sauce du rôti de viande hachée :
2 c. à soupe de beurre
4 échalotes en cube
1 brin de thym
50 g de poivron rouge en cube
70 g de ketchup
1 c. à café de poivre
2 c. à café d'ail haché
500 ml de bouillon de volaille
2 tomates, épluchées et coupées en cubes

Faire blondir dans une poêle le beurre, les échalotes, l'ail, le poivron, le thym, le sel et le poivre. Ajouter le bouillon et faire réduire à grande chaleur. Mélanger le ketchup et les tomates et continuer de faire cuire à feu doux. Faire cuire 20 minutes couvert. Verser ensuite dans une passoire et garder au chaud.

1 cucharada de mantequilla
100 g de cebolleta, cortada
100 g de cebollas, cortadas
100 g de zanahorias, cortadas
100 g de pimiento rojo, cortado
2 cucharaditas de ajo picado
1 cucharadita de sal
1 cucharadita de pimienta
1/2 cucharadita de pimienta de cayena
2 huevos
70 g de ketchup
1 kg de carne de pavo magro, picada

Mezclar los primeros seis ingredientes y freír en una sartén hasta dorarse. Dejar enfriar.
Mezclar en una fuente la sal, la pimienta, la pimienta de cayen, los huevos y el ketchup, añadir la carne de pavo y la verdura y formar una hogaza. Colocar la hogaza en una bandeja engrasada y asar a 180 °C durante aprox. 45–60 minutos. Dejar reposar 30 minutos antes de servir.

Salsa para el asado de carne picada:
2 cucharadas de mantequilla
4 chalotas cortadas en cuadraditos
1 ramito de tomillo
50 g de pimiento rojo cortado en cuadraditos
70 g de ketchup
1 cucharadita de pimienta
2 cucharaditas de ajo picado
500 ml de caldo de ave
2 tomates, pelados y cortados en cuadraditos

Rehogar en una sartén la mantequilla, las chalotas, el ajo, el pimiento, el tomillo, la sal y la pimienta hasta que queden blandos. Agregar el caldo y reducir un cuarto a fuego fuerte. Añadir el ketchup y los tomates, mezclar y dejar cocer a fuego lento. Tapar la sartén y dejar cocer 20 minutos. Seguidamente, pasar por un colador y mantener caliente.

1 cucchiaio di burro
100 g di cipollotti, tagliati
100 g di cipolle, tagliate
100 g di carota, tagliata
100 g di peperone rosso, tagliato
2 cucchiaini di aglio tritato
1 cucchiaino di sale
1 cucchiaino di pepe
1/2 cucchiaino di pepe cayenne
2 uova
70 g di ketchup
1 kg di carne di tacchino macinata

Mescolate i primi sei ingredienti e fateli saltare in padella. Fateli raffreddare.
In una scodella amalgamate il sale, il pepe, il pepe di cayenne, le uova ed il ketchup, aggiungete la carne di tacchino e la verdura e date all'impasto la forma del polpettone. Appoggiatelo in una pirofila precedentemente unta e fatelo cuocere per 45-60 minuti nel forno a 180 °C.

Prima di servirlo, fatelo riposare per 30 minuti.

La salsa per il polpettone:
2 cucchiai di burro
4 scalogne, tagliate a dadini
1 rametto di timo
50 g di peperone rosso tagliato a dadi
70 g di ketchup
1 cucchiaino di pepe
2 cucchiaini di aglio tritato finemente
500 ml di brodo di gallina
2 pomodori, sbucciati e tagliati a dadi

In una padella fate appassire ed ammorbidire le scalogne, il aglio, il peperone, timo, sale e pepe. Aggiungete il brodo e fatelo ridurre di un quarto a fuoco molto vivace. Unitevi il ketchup ed i pomodori e continuate la cottura a fuoco moderato per 20 minuti, mantenendo il recipiente coperto. Fate passare il liquido attraverso un setaccio e tenetelo al caldo.

A.O.C.

Design: Barbara Barry
Owners: Suzanne Goin, Caroline Styne | Chef: Suzanne Goin

8022 W Third St / Crescent Heights Blvd | Los Angeles, CA 90048-4307
Phone: +1 323 653 6359
Opening hours: Mon–Fri 6 pm to 11 pm, Sat 5:30 pm to 11 pm,
Sun 5:30 pm to 10 pm
Average price: $ 38
Cuisine: Mediterranean, tapas
Special features: Celeb hangout, patio dining, valet parking

Cucumber & Avocado

with Green Goddess Dressing

Avocado Salat mit Gurken
und „grüner Göttinnen-Sauce"

Salade d'avocats et de concombres
et sa « sauce verte déesses »

Ensalada de aguacate con pepino
y "salsa diosa verde"

Insalata di avocado con cetrioli
e "salsa verde divina"

1 egg yolk
1 cup grapeseed oil
Juice of 1 lemon
1 cup parsley
1/3 bunch picked cleaned watercress
2 tbsp tarragon leaves
3 tbsp minced chives
2 anchovy filets
1 1/2 tbsp champagne vinegar
3 medium ripe avocados
2 large cucumbers
2 bunches watercress cleaned

Whisk the egg yolk in a clean bowl. Measure 1/2 cup of oil and slowly drizzle it into the yolk, whisking all the time to emulsify and make a mayonnaise. Squeeze the juice of one lemon into the mayonnaise and whisk to combine.
Purée the parsley leaves, a third bunch picked watercress, tarragon and chives in a blender with the anchovies and the remaining a half cup of oil. Whisk the herb purée, vinegar, two teaspoons salt and a half teaspoon freshly ground black pepper into the mayonnaise. Taste for seasoning and adjust.
Slice the avocado into wedges. Cut the cucumber in half lengthwise, scoop out the seeds and cut into half-moons on the bias. Season the avocado and cucumber generously with salt, pepper and lemon.
Place the avocado and cucumber in a large salad bowl and toss gently with three fourth cup of the dressing, a fourth teaspoon salt and freshly ground black pepper. Gently toss in the watercress. Add a little more dressing if necessary. Taste for seasoning and plate on six chilled salad plates.

1 Eigelb
250 ml Traubenkernöl
Saft einer Zitrone
100 g Petersilie
1/3 Bund gezupfte, gewaschene Brunnenkresse
2 EL Estragonblätter
3 EL Schnittlauchröllchen
2 Anchovis
1 1/2 EL Champagneressig
3 fast reife Avocados
2 große Salatgurken
2 Bund Brunnenkresse, gezupft und gewaschen

Das Eigelb in einer sauberen Schüssel aufschlagen. Die Hälfte des Öls hineintröpfeln lassen und dabei ständig rühren, um die Mayonnaise herzustellen. Den Zitronensaft hinzugeben und verrühren.
Die Petersilie, ein Drittel Bund Brunnenkresse, den Estragon und den Schnittlauch mit den Anchovis in einen Mixer geben und mit dem restlichen Öl pürieren.
Das Kräuterpüree mit dem Essig, zwei Teelöffel Salz und einen halben Teelöffel frisch gemahlenem Pfeffer in die Mayonnaise rühren. Abschmecken.
Die Avocados in Scheiben schneiden. Die Gurken halbieren, die Kerne entfernen und schräg in Halbmonde schneiden. Die Avocado und Gurke kräftig mit Salz, Pfeffer und Zitrone würzen.
Die Avocados und Gurken in eine Salatschüssel geben und vorsichtig mit 175 g Dressing mischen. Abschmecken. Die Brunnenkresse unterheben. Falls nötig etwas mehr Dressing zugeben. Abschmecken und auf gekühlten Tellern anrichten.

1 jaune d'oeuf
250 ml d'huile de pépins de raisin
Le jus d'un citron
100 g de persil
1/3 de bouquet de cresson de fontaine lavé et sans les racines
2 c. à soupe de feuilles d'estragon
3 c. à soupe de ciboulette finement coupée
2 anchois
1 1/2 c. à soupe de vinaigre de champagne
3 avocats presque murs
2 gros concombres
2 bouquets de cresson de fontaine lavés et sans les racines

Battre le jaune d'oeuf dans un saladier propre. Verser goutte à goutte la moitié de l'huile tout en remuant pour obtenir la mayonnaise. Ajouter le jus de citron et mélanger.

Mettre le persil, un tiers de bouquet de cresson de fontaine, l'estragon et la ciboulette avec les anchois dans un mixeur et réduire en purée avec le reste de l'huile.
Verser la purée de fines herbes avec le vinaigre, deux cuillères à café de sel et un demi cuillère à café de poivre fraîchement moulu dans la mayonnaise et mélanger. Assaisonner.
Couper les avocats en tranches. Couper les concombres en deux, retirer les pépins et couper de biais en demi-lunes. Assaisonner énergiquement les avocats et les concombres avec du sel, du poivre et du citron.
Mettre les avocats et les concombres dans un saladier et mélanger délicatement avec 175 g de sauce vinaigrette. Assaisonner. Ajouter le cresson de fontaine. Si nécessaire, ajouter un peu plus de vinaigrette. Assaisonner et présenter sur assiettes refroidies.

1 yema de huevo
250 ml de aceite de semilla de uva
El zumo de un limón
100 g de perejil
1/3 de manojo de berros de fuente lavados y despojados de los tallos
2 cucharadas de estragón
3 cucharadas de rollitos de cebollino
2 anchoas
1 1/2 cucharadas de vinagre de champán
3 aguacates casi maduros
2 pepinos grandes
2 manojos de berros de fuente lavados y despojados de los tallos

Batir la yema de huevo en una fuente limpia. Agregar poco a poco la mitad del aceite removiendo constantemente para obtener la mayonesa. Añadir ahora el zumo de limón y remover.

Picar con la batidora el perejil, un tercio de un manojo de berros de fuente, el estragón, el cebollino y las anchoas y añadir el resto del aceite hasta conseguir un puré.
Agregar el puré de hierbas junto con el vinagre, dos cucharaditas de sal y media cucharadita de pimienta fresca a la mayonesa y remover. Probar para comprobar si está bien sazonada.
Cortar los aguacates en rodajas. Partir los pepinos por la mitad, eliminar las semillas y cortarlos oblicuamente en medias lunas. Sazonar bien los aguacates y el pepino con sal, pimienta y limón.
Introducir los aguacates y el pepino en una fuente de ensalada y añadir cuidadosamente 175 g de la salsa para la ensalada. Probar. Agregar los berros. Si fuera necesario, aliñar con algo más de salsa. Probar y aderezar en platos fríos.

1 tuorlo
250 ml di olio di vinaccioli
Succo di un limone
100 g di prezzemolo
1/3 di un mazzetto di crescione lavato
2 cucchiai di foglie di dragoncello
3 cucchiai di erba cipollina tagliata a piccole rondelle
2 filetti di acciughe
1 1/2 cucchiai di aceto allo champagne
3 avocado quasi maturi
2 grandi cetrioli da insalata
2 mazzetti di crescione lavato

Montate il tuorlo in una scodella accuratamente pulita. Integratevi l'olio a gocce e continuate a montare il tuorlo in modo da produrre la maionese. Aggiungete il succo di limoni e mescolate.

Mettete il prezzemolo, il terzo di un mazzetto di crescione, il dragoncello e l'erba cipollina nel frullatore e frullate il tutto insieme al resto dell'olio.
Aggiungete il frullato di erbe miste alla maionese, insieme all'aceto, due cucchiaini di sale e mezzo cucchiaino di pepe macinato. Assaggiatelo ed aggiustate.
Tagliate gli avocado a fettine. Tagliate i cetrioli a metà nel senso longitudinale, privateli dai semi ed ora tagliateli in diagonale, a forma di semiluna. Aggiustate l'avocado ed il cetriolo abbondantemente con sale, pepe e limone.
Ponete gli avocado ed i cetrioli in una insalatiera e mescolateli con cautela con 175 ml del dressing. Assaggiateli ed aggiustate. Ora integratevi il crescione. Se necessario, aggiungete altro dressing. Assaggiate, aggiustate e servite su piatti fatti leggermente raffreddare.

AXE

Design, Owner & Chef: Joanna Moor

1009 Abbot Kinney Blvd | Venice, CA 90291-3372
Phone: +1 310 664 9787
www.axerestaurant.com
Opening hours: Lunch Tue–Fri 11:30 am to 3 pm, dinner Tue–Thu 6 pm to 10 pm,
Fri–Sat 6 pm to 10:30 pm, Sun 5:30 pm to 9:30 pm, brunch Sat–Sun 9 am to 3 pm,
closed on Monday
Average price: $ 25
Cuisine: Californian

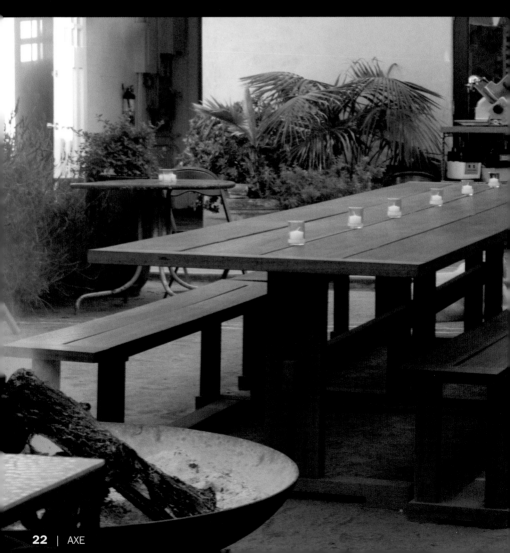

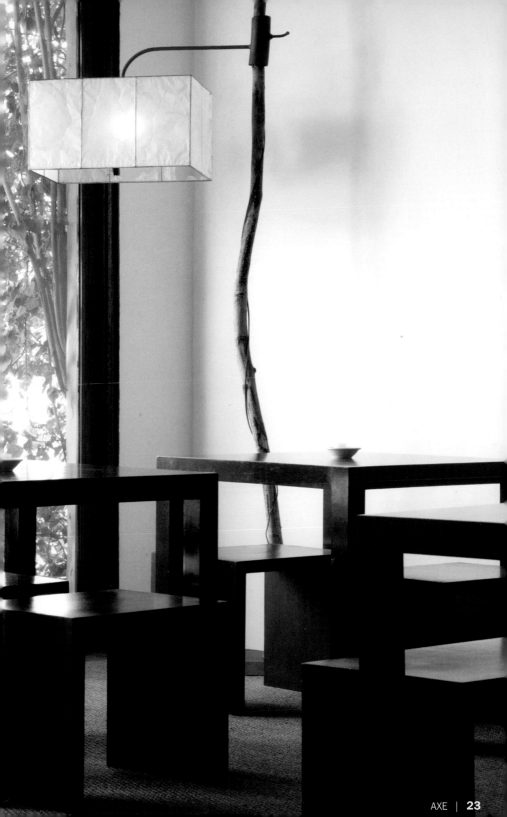

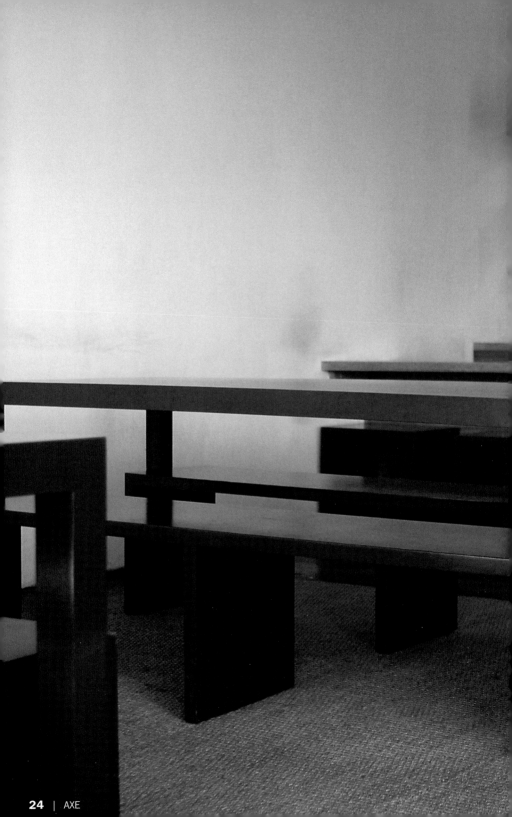

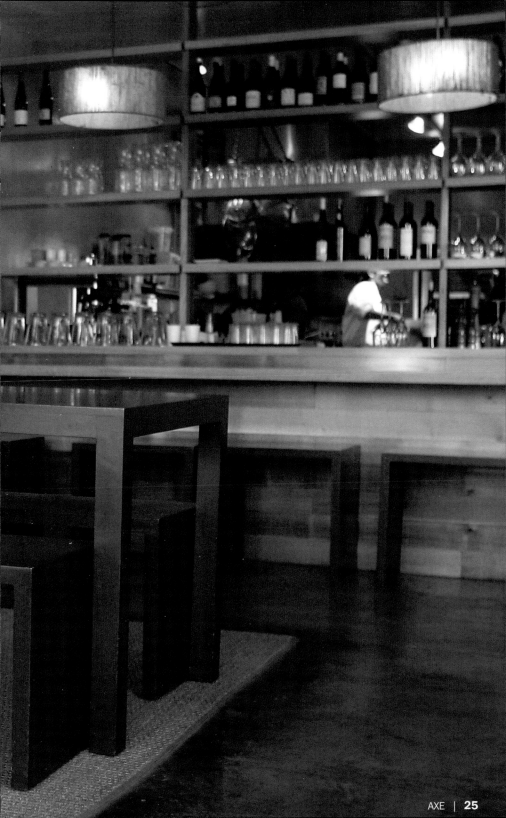

Balboa

Design: Tag Front Architects, www.tagfront.com
Chef: Gabriel Morales

8462 W Sunset Blvd | West Hollywood, CA 90069
Phone: +1 323 6508383
www.balboaprime.com
Opening hours: Every day 7 am to 3 pm, 5 pm to midnight
Special features: Late night dining, celeb hangout, valet parking
Average price: $ 48
Cuisine: American steakhouse

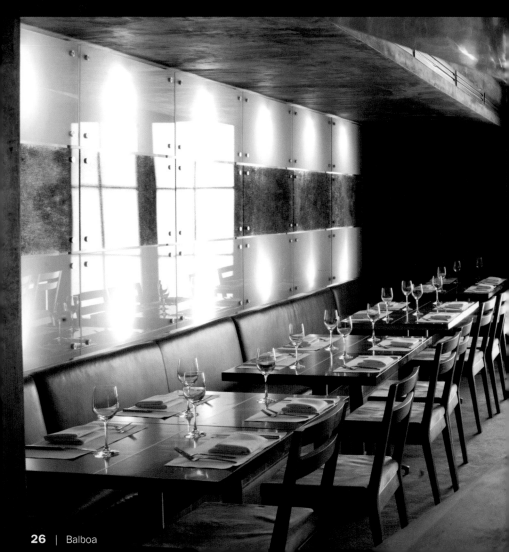

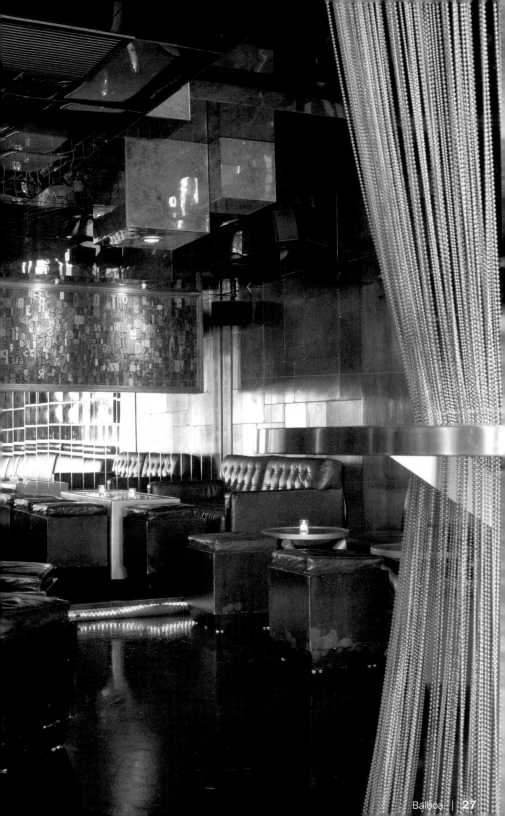

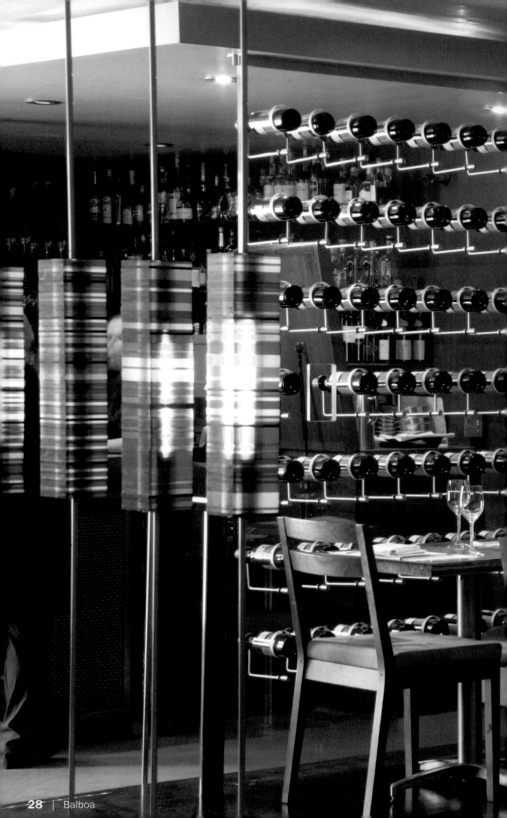

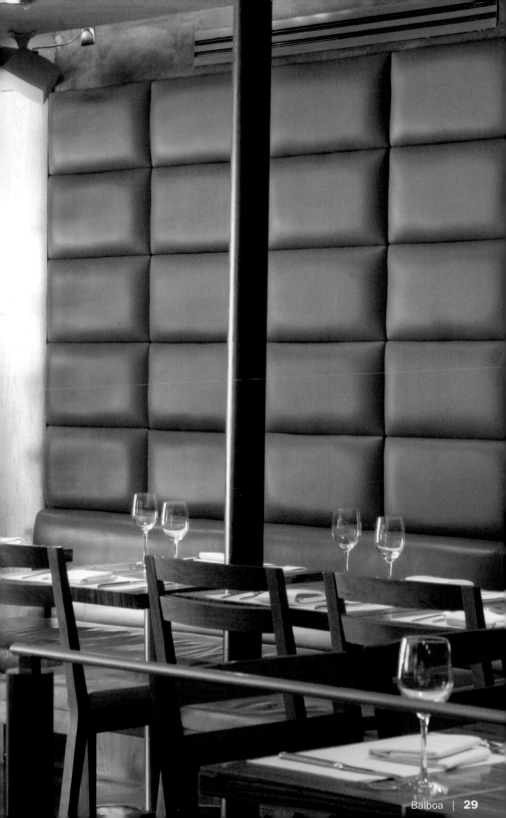

Bar Marmont

Design: Shawn Haussman | Chef: Kelly Frazer

8171 W Sunset Blvd | West Hollywood, CA 90046-2415
Phone: +1 323 650 0575
Opening hours: Mon–Sat 6 pm to 2 am, Sun 7 pm to 2 am
Average price for a meal: $ 26
Cuisine: Californian
Special features: Martini Bar, 21 and over

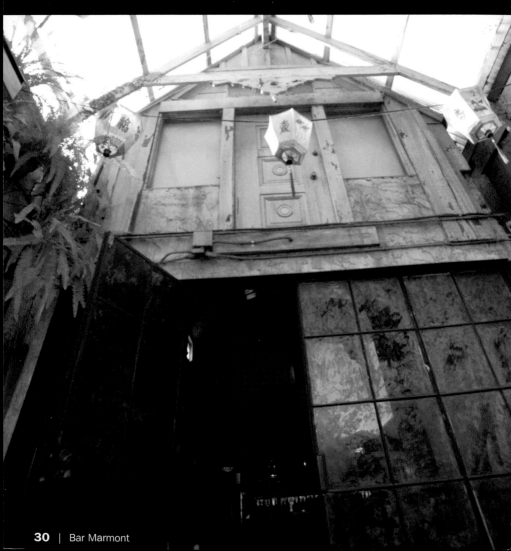

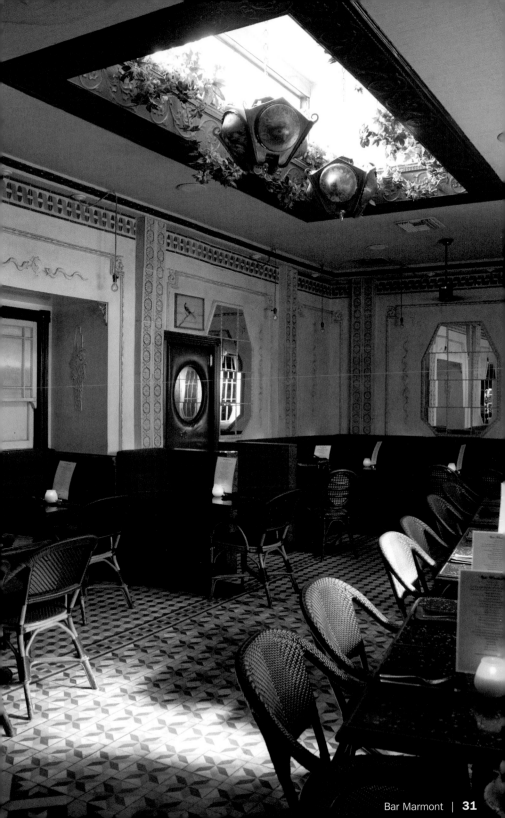

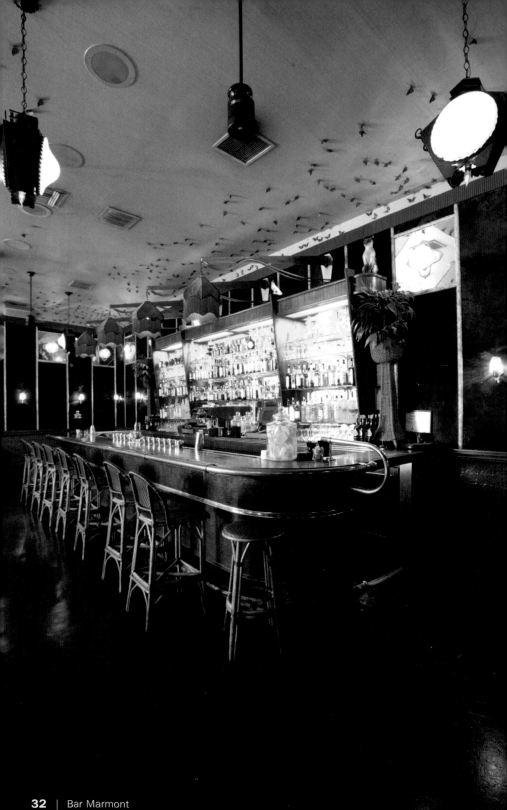

Bastide

Design: Andrée Putman | Chef: Alain Giraud

8475 Melrose Pl / La Cienega Blvd | West Hollywood, CA 90069
Phone: +1 323 651 5950
Opening hours: Tue–Sat 6 pm to 9 pm
Special features: Private rooms, celeb hangout, outdoor dining, chef's table
Average price: $ 48
Cuisine: French provencal

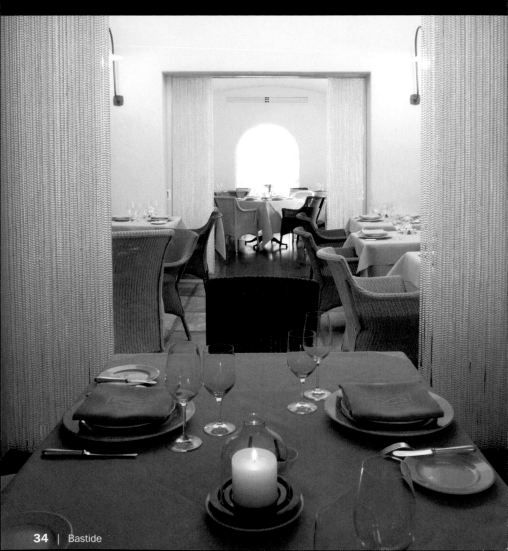

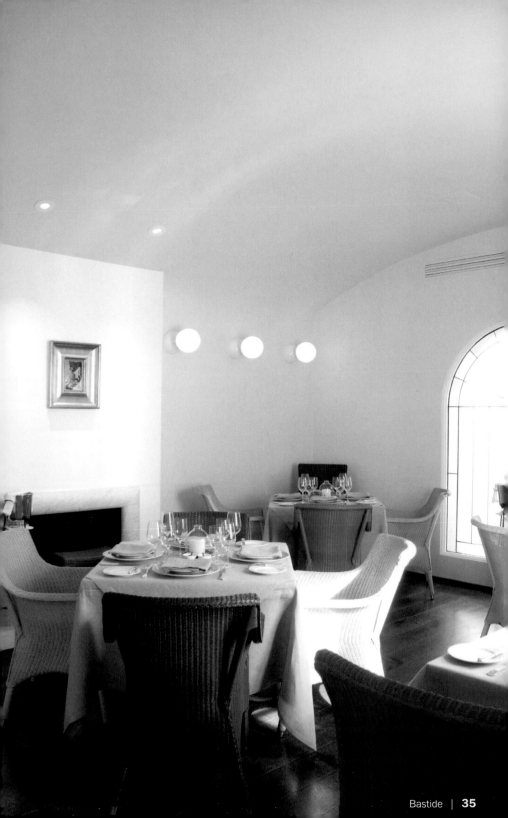

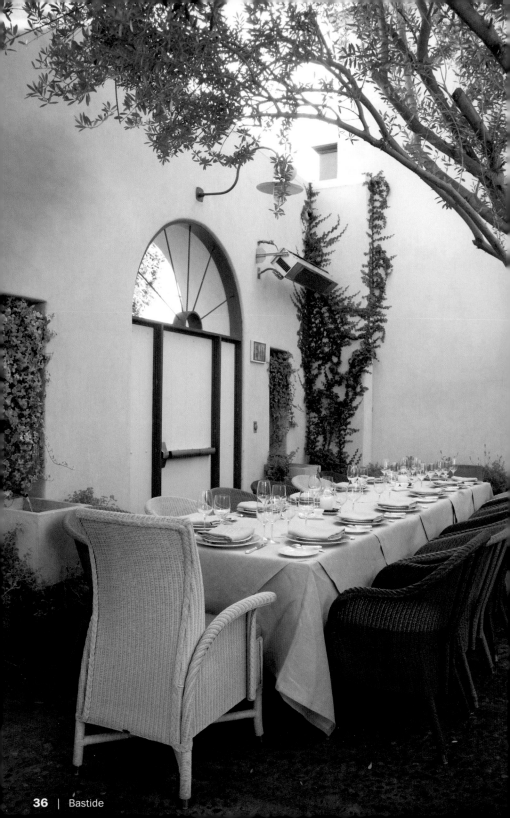

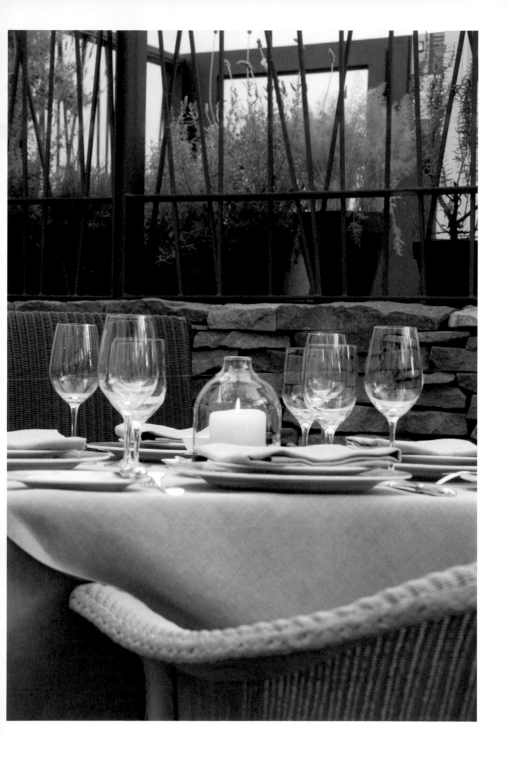

Vacherin Ice Cream

Vacherin Eiscreme
Vacherin glacé
Helado Vacherin
Gelato alla Vacherin

Lavender Ice Cream:
1 1/2 cups milk
1/2 cup heavy cream
1/2 vanilla pod
4 egg yolks
1/8 cup sugar
1 1/2 tsp dried lavender
Bring milk, cream, vanilla and half of the sugar to a boil. Add the lavender, turn heat off and infuse for one minute. In a separate bowl, combine yolks and sugar. Prepare a bowl of ice water, set an empty bowl on top of the ice water and place a strainer on top of the empty bowl. Temper the yolk and sugar with a small amount of the warm mixture above, being careful not to cook or scramble the eggs. Bring the milk/cream mixture back to a boil and stir in the tempered yolk mixture. Cook, mixing continuously with a wooden spoon, until the mix coats the back of a spoon, about three minutes. Strain mixture into the empty bowl and chill. Run mixture in an ice cream machine until set, and place in freezer.

Raspberry Coulis:
10 oz fresh raspberries
1 tbsp lemon juice, sugar
In a blender, place the raspberries, sugar and lemon juice. Blend at high speed until smooth. Strain. Taste and adjust for flavor.

Meringue drops:
1/2 cup sugar
2 large egg whites
Beat egg whites soft peaks. Add sugar and keep beating until stiff. Sugar has to be dissolved. Use a pastry bag to pipe onto a parchment-lined sheet in to teardrop shape. Dry at 175 °F.

For garnish:
16 fresh strawberries, lavender sprigs, meringue drops, whipped cream

Lavendeleis:
375 ml Milch
125 ml Sahne
1/2 Vanillestange
4 Eigelb
30 g Zucker
1 1/2 TL getrockneter Lavendel
Die Milch, Sahne, Vanilleschote und die Hälfte des Zuckers zum Kochen bringen. Den Lavendel hinzugeben, ausschalten und für eine Minute ziehen lassen. In einer Schüssel die Eigelbe und den Zucker verrühren. Ein Eiswasserbad vorbereiten. Die Ei-Zuckermischung mit etwas warmer Milch temperieren und darauf achten die Eier nicht zu kochen oder gerinnen zu lassen. Die Milch-Sahne wieder zum Kochen bringen und die Eiermischung einrühren. Unter ständigem Rühren aufkochen bis die Flüssigkeit eindickt (ca. drei Minuten). Durch ein Sieb gießen und im Wasserbad abkühlen lassen. Die Flüssigkeit in eine Eismaschine füllen und gefrieren lassen. Kaltstellen.

Himbeerragout:
300 g frische Himbeeren
1 EL Zitronensaft, Zucker
Die Himbeeren, den Zucker und den Zitronensaft in einen Mixer geben und pürieren. Durch ein Sieb streichen und abschmecken.

Baisertropfen:
120 g Zucker
2 Eiweiß
Eiweiß halbfest schlagen, Zucker einrieseln lassen und steif schlagen. Mit einem Spritzbeutel tränenförmige Tropfen auf ein Backblech spritzen. Bei ca. 80 °C trocknen lassen.

Für die Garnitur:
16 frische Erdbeeren, Lavendelzweige, Baisertropfen, Schlagsahne

Glace à la lavande :
375 ml de lait
125 ml de crème
1/2 gousse de vanille
4 jaunes d'oeufs
30 g de sucre
1 1/2 c. à café de lavande séchée
Porter à ébullition le lait, la crème, la gousse de vanille et la moitié du sucre. Ajouter la lavande et faire macérer pendant une minute. Mélanger dans un saladier le jaune d'œuf et le sucre. Préparer un bain d'eau glacée. Tempérer le mélange d'œuf et de sucre avec un peu de lait chaud et veiller à ne pas laisser l'œuf cuire ou se figer. Porter de nouveau la crème de lait à ébullition et y ajouter le mélange d'œuf. Faire cuire en remuant constamment jusqu'à ce que le liquide épaississe (env. trois minutes). Verser dans une passoire et laisser refroidir dans le bain d'eau. Verser le liquide dans une sorbetière et faire congeler. Mettre à refroidir.

Coulis de framboise :
300 g de framboises fraîches
1 c. à soupe de jus de citron, sucre
Verser les framboises, le sucre et le jus de citron dans un mixeur et mouliner. Faire passer dans une passoire et assaisonner.

Meringues :
120 g de sucre
2 blancs d'oeuf
Battre les blancs d'oeuf en demi-ferme, verser le sucre en pluie et battre jusqu'à obtention d'un mélange ferme. Déposer des gouttes en forme de larme avec une poche à douille. Faire sécher à environ 80 °C.

Pour la garniture :
16 fraises fraîches, brins de lavande, meringues, crème chantilly

Helado de lavanda:
375 ml de leche
125 ml de nata
1/2 vaina de vainilla
4 yemas de huevo
30 g de azúcar
1 1/2 cucharitas de lavanda seca
Poner a calentar la leche junto con la nata, la vaina de vainilla y la mitad del azúcar hasta que rompa a hervir. Añadir la lavanda, apagar el fuego y dejar reposar un minuto. En una fuente mezclar las yemas de huevo y el azúcar. Preparar un baño de agua helada. Templar la mezcla de huevo y azúcar con algo de leche caliente y asegurarse de que los huevos no empiecen a hervir o se cuajen. Volver a poner a hervir la leche con la nata y seguidamente agregar la mezcla del huevo. Remover constantemente hasta que rompa a hervir y se espese el líquido (aprox. tres minutos). Pasar por un colador y dejar enfriar en el baño de agua helada. Introducir el líquido en una heladera y dejar que se congele. Mantener frío.

Ragú de frambuesas:
300 g de frambuesas frescas
1 cucharada de zumo de limón, azúcar
Batir las frambuesas, el azúcar y el zumo de limón con la batidora hasta obtener un puré. Colar y sazonar.

Gota de merengue:
120 g de azúcar
2 claras de huevo
Batir las claras de huevo hasta que queden medio montadas, añadir el azúcar y batir a punto de nieve. Sobre una bandeja de horno formar gotas en forma de lágrima con una manga. Dejar que se sequen a 80 °C.

Para la guarnición:
16 fresas frescas, ramitos de lavanda, gotas de merengue, nata batida

Gelato alla lavanda:
375 ml di latte
125 ml di panna da montare
1/2 stecca di vaniglia
4 tuorli
30 g di zucchero
1 1/2 cucchiaino di lavanda seccata
Portate ad ebollizione il latte, la panna, la stecca di vaniglia e metà dello zucchero. Aggiungete la lavanda, spegnete il fuoco e fate riposare il tutto per un minuto. In una scodella montate i tuorli con lo zucchero rimanente. Preparate un recipiente con acqua fredda e cubetti di ghiaccio. Portate a temperatura con poco latte tiepido i tuorli mescolati con lo zucchero e fate attenzione a non fare cuocere le uova ed a non farle impazzire. Fate nuovamente bollire il latte alla panna ed unitevi la crema all'uovo. Portate il liquido ad ebollizione mescolando in continuazione, fino a farlo ispessire (dopo circa tre minuti). Passatelo attraverso il setaccio e fatelo raffreddare a ba-gnomaria nell'acqua ghiacciata. Versate il liquido nella macchina per il gelato e fatelo congelare. Mettete il gelato al freddo.

Crema di lamponi:
300 g di lamponi freschi
1 cucchiaio di limone, zucchero
Mettete i lamponi, lo zucchero ed il succo di limoni nel frullatore e frullate. Fate passare il liquido attraverso il setaccio ed aggiustate di zucchero.

Gocce di meringa:
120 g di zucchero
2 albumi
Montate gli albumi a neve senza farli diventare troppo densi, unitevi lentamente lo zucchero e continuate a montarli fino a farli ispessire. Con un sacchetto per decorare spruzzate delle gocce a forma di lacrime sulla teglia. Fate prosciugare le meringhette al forno a 80 °C.

Per la guarnizione:
16 fragole fresche, rametti di lavanda, le gocce di meringa, panna montata

Campanile

Design: Josh Schweitzer | Chef: Mark Peel, Nancy Silverton

624 S La Brea Ave / Wilshire Blvd | Los Angeles, CA 90036
Phone: +1 323 938 1447
www.campanilerestaurant.com
Opening hours: Mon–Thu 11:30 am to 2:30 pm, 6 pm to 10 pm,
Fri 11:30 am to 2:30 pm, 5:30 pm to 11 pm, Sat 9:30 am to 1:30 pm,
5:30 pm to 11 pm, Sun 9:30 am to 1:30 pm
Average price: $ 48
Cuisine: Californian, Mediterranean
Special features: Brunch, private rooms, celeb hangout

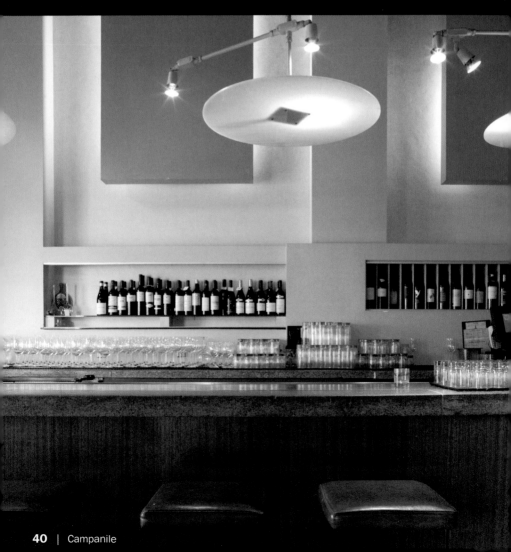

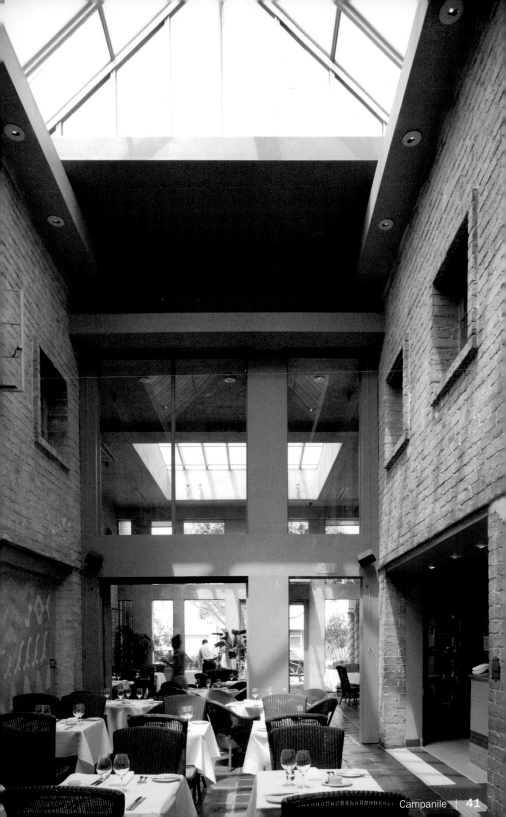

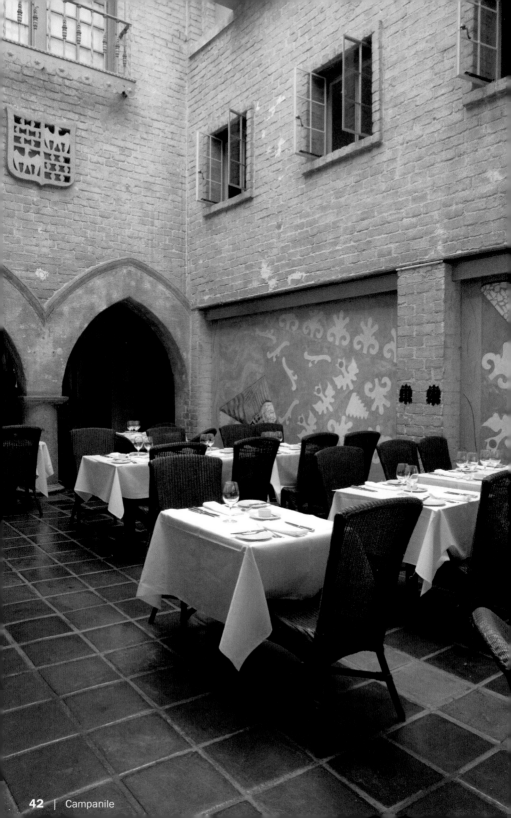

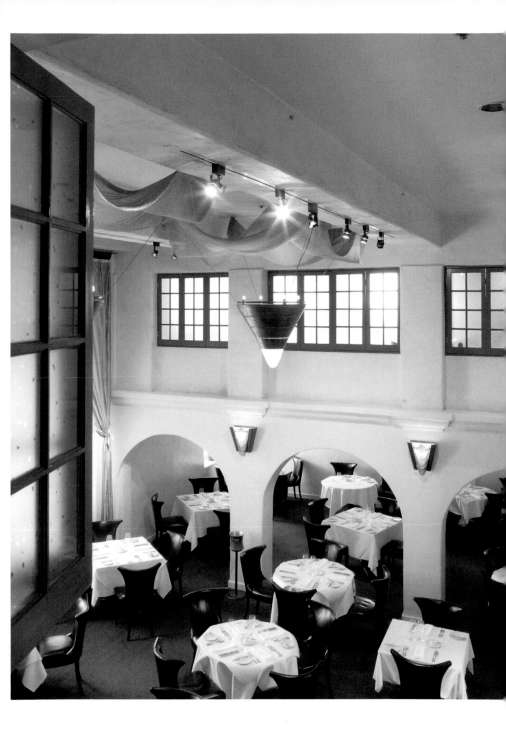

ChoSun Galbee

Design: Richard Cutts Lundquist, studio rcl, www.rcl.net
Owner: Kyong M. Ji | Chef: Yeung Pil Ji

3330 W Olympic Blvd / S. Manhattan Place | Los Angeles, CA 90019
Phone: +1 323 734 3330
www.chosungalbee.com
Opening hours: Every day 11 am to 11 pm
Average price: $ 35
Cuisine: Korean BBQ
Special features: Outdoor dining, kid friendly

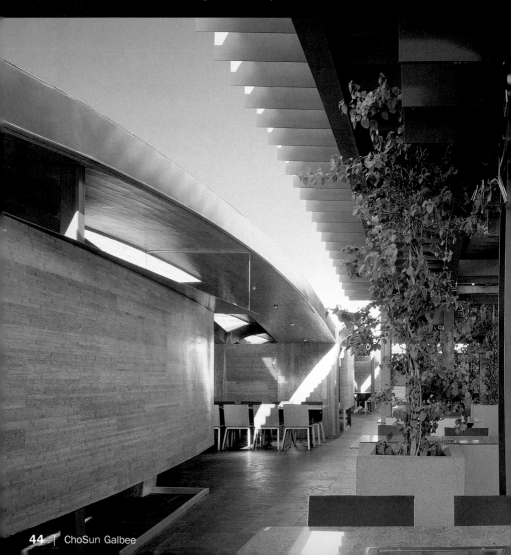

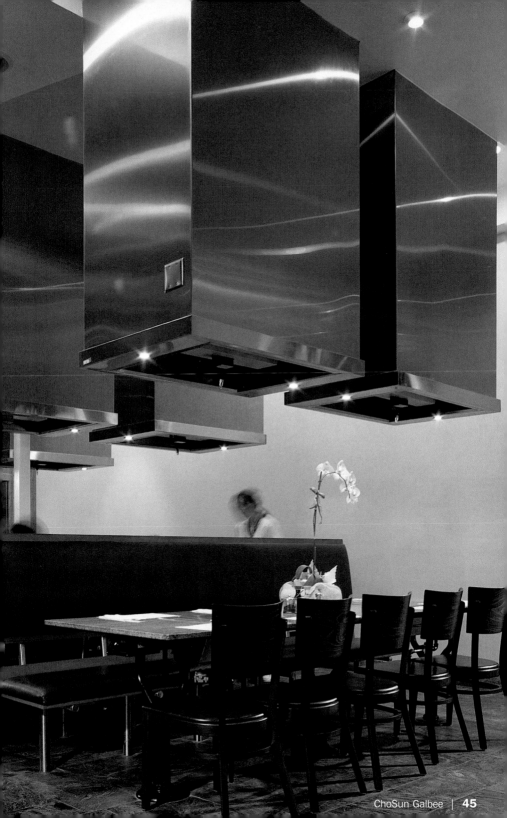

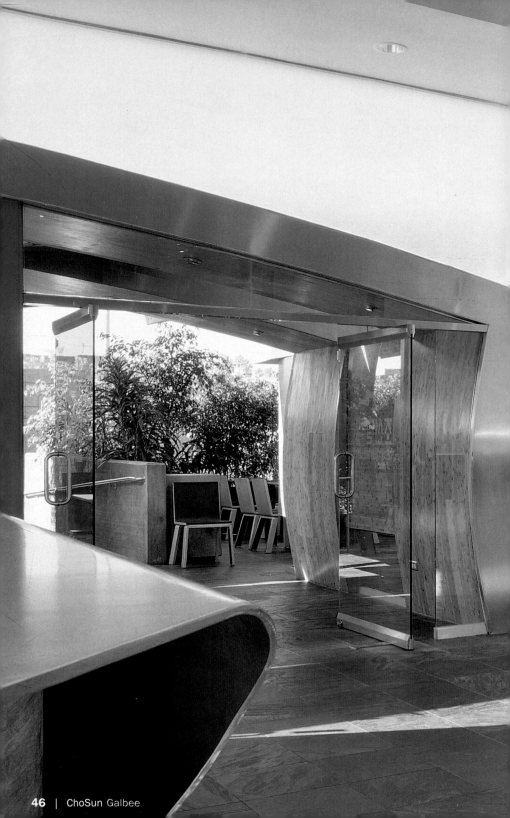

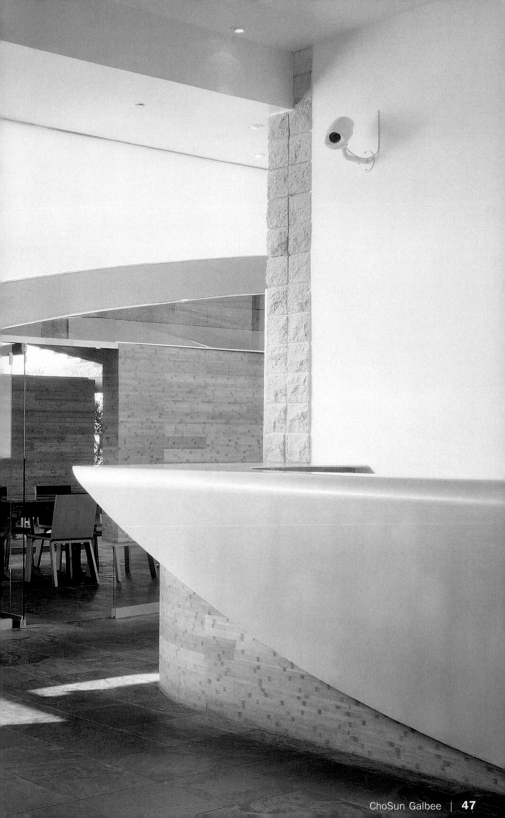

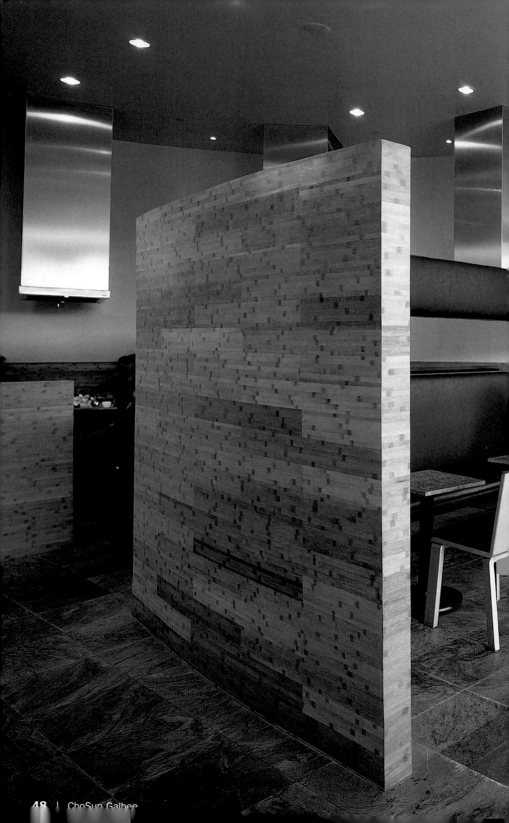

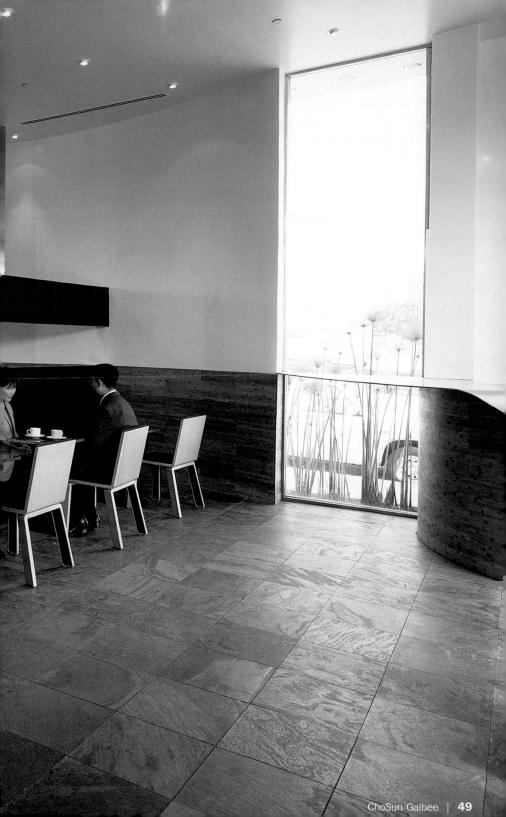

Cinch

Design: Dodd Mitchell | Chef: Chris Behre

1519 Wilshire Blvd / 15th St | Santa Monica, CA 90403
Phone: +1 310 395 4139
www.cinchrestaurant.com
Opening hours: Sun–Thu 6 pm to 10 pm, Fri–Sat 6 pm to 11 pm,
Bar: Every day 5 pm to 1:30 am
Special features: Group dining, valet parking
Average price: $ 35
Cuisine: International, French, Japanese

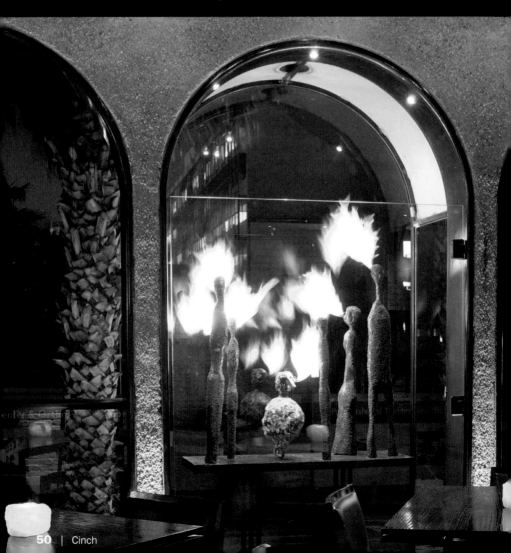

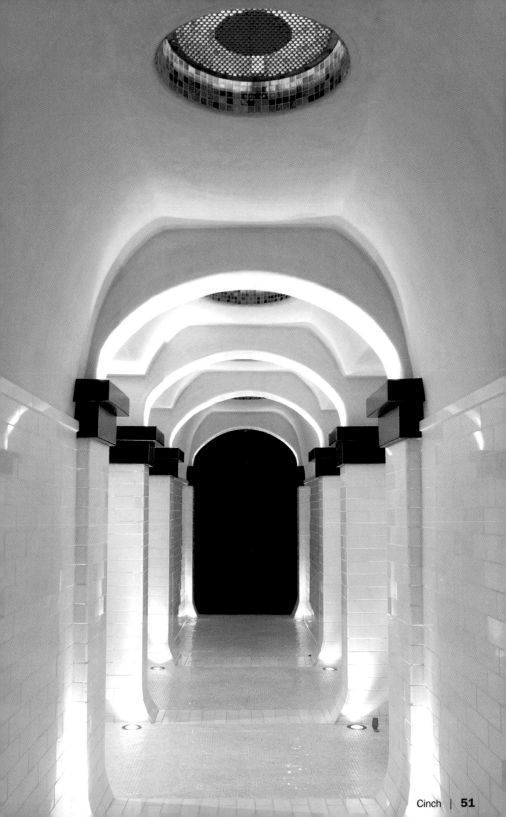

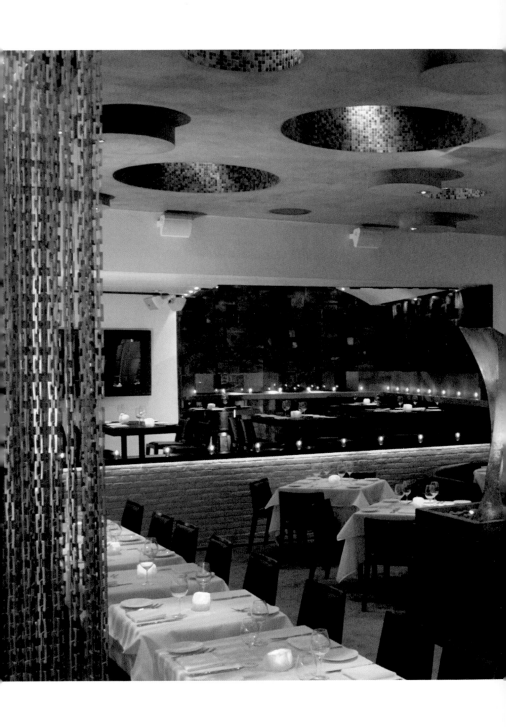

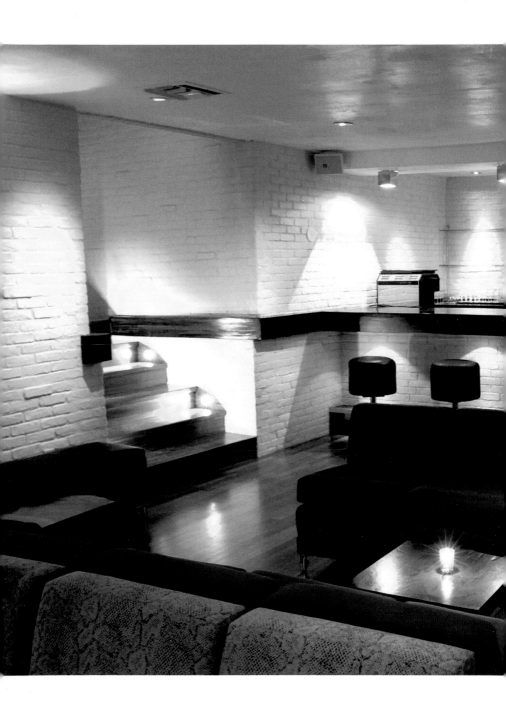

Chocolate Pudding

with Double Chocolate Meringues and Plum Wine Poached Pears

Schokoladenpudding mit Schokoladenbaiser und pochierten Birnen

Crème au chocolat avec meringue chocolatée et ses poires pochées

Pudín de chocolate con merengue de chocolate y peras escalfadasital

Budino al cioccolato con meringhe di cioccolato e pere sciroppate

Double Chocolate Meringues:
3 egg whites
1 cup sugar (granulated)
1 1/2 cups chocolate chips
3 tbsp cocoa powder
Preheat oven to 350 °F
In a small electric mixer whip egg whites to soft peaks. Slowly rain in sugar. Mix on low until sugar dissolves and meringue looks shiny and smooth. Sift cocoa and the chocolate chips into meringue and finish folding gently. Use two large spoons to portion one large spoonful onto a cookie tray by scraping the scoop out with the back of the empty spoon. Reduce oven temperature to 325 °F bake meringues for approximately 20 minutes. Cool.
Chocolate Pudding:
2 cups heavy cream
1/4 cup sugar
5 egg yolks
3 oz chocolate (dark at least 60%)
1 vanilla pod

In a small sauce pot, heat heavy cream, sugar and vanilla pod until it comes to a simmer. Pour 1/4 th of the cream into the yolks. Mix quickly with a wire whisk. Return mixture to the pot on the stove. Cook mixture until thick enough to coat the back of a spoon. Strain unto a shallow dish and wrap with plastic.
Plum Wine Poached Pears:
4 pears
2 cups sugar
2 cups water
2 cups plum wine
3 tbsp star anise
Peal pears and remove core. Cut pears in half from top to bottom. Bring the sugar, water, and star anise to a boil. Add the plum wine and pears. Cover pot and cook at a low simmer until fork tender.

Baisermasse:
3 Eiweiß
200 g Zucker
225 g Schokotropfen
3 EL Kakao
Ofen auf 180 °C vorheizen.
Eiweiß halbfest schlagen, dann langsam den Zucker unterrühren bis das Eiweiß steif ist und der Zucker sich aufgelöst hat. Das Kakaopulver und die Schokotropfen vorsichtig unterheben. Mit zwei großen Löffeln die Baisermasse auf ein gefettetes Backblech portionieren und mit dem Löffelrücken gleichmäßig verteilen. Die Temperatur auf 160 °C herunterdrehen und ca. 20 Minuten backen. Auskühlen lassen.
Schokopudding:
500 ml Schlagsahne
50 g Zucker
5 Eigelb
85 g dunkle Kuvertüre (mind. 60%)
1 Vanilleschote

Die Vanilleschote aufschlitzen und in einem Topf mit der Sahne, der Schokolade und dem Zucker erhitzen. 1/4 der Sahne mit den Eigelben zügig verrühren und zurück in den Topf geben. Nun die Eigelb/Sahne-Mischung zum Kochen bringen, bis sie dickflüssig ist. In eine flache Form geben, mit Folie abdecken und kaltstellen.
Pochierte Birnen:
4 Birnen
400 g Zucker
500 ml Wasser
500 ml Pflaumenwein
3 TL Sternanis
Die Birnen schälen, halbieren und das Kerngehäuse entfernen. Wasser, Zucker und Sternanis aufkochen. Die Birnen und den Pflaumenwein hinzufügen und bissfest garen. Im Sud abkühlen lassen.

Pâte à meringue :
3 blancs d'oeuf
200 g de sucre
225 g de pépites de chocolat
3 c. à soupe de cacao
Faire préchauffer le four à 180 °C.
Battre les blancs d'oeuf en demi-ferme, puis
ajouter peu à peu le sucre jusqu'à ce que le blanc
d'œuf soit ferme et que le sucre se soit dissous.
Mélanger prudemment la poudre de cacao et les
pépites de chocolat. Répartir à parts égales la
pâte à meringue avec deux grandes cuillères sur
une plaque de cuisson graissée et fignoler avec le
dos de la cuillère. Amenez la température du four
à 160 °C et faire cuire pendant environ 20 minu-
tes. Laisser refroidir.
Crème au chocolat :
500 ml de crème
50 g de sucre
5 jaunes d'oeuf
85 g de chocolat de cuisson noir (60% min.)

1 gousse de vanille
Fendre la gousse de vanille et faire chauffer dans
une casserole avec la crème, le chocolat et le
sucre. Mélanger énergiquement $1/4$ de la crème
aux jaunes d'oeuf puis reverser le mélange dans
la casserole. Faire cuire ensuite le mélange de
crème et de jaune d'oeuf, jusqu'à ce que celui-ci
prenne une consistance visqueuse. Verser dans
un moule plat, recouvrir d'une feuille de cuisson
et mettre à refroidir.
Poires pochées :
4 poires
400 g de sucre
500 ml d'eau
500 ml de vin de prune
3 c. à café d'anis étoilé
Eplucher les poires, les couper en moitiés et reti-
rer le trognon. Porter à ébullition l'eau, le sucre et
l'anis étoilé. Ajouter les poires et le vin de prune
puis faire cuire jusqu'à ce que celles-ci soient
agréables au goût. Faire refroidir dans le jus.

Masa del merengue:
3 claras de huevo
200 g de azúcar
225 g de gotas de chocolate
3 cucharadas de cacao
Precalentar el horno a 180 °C.
Batir las claras de huevo hasta que queden
medio montadas, agregar lentamente el azúcar
hasta que las claras queden batidas a punto de
nieve y se haya disuelto el azúcar. Agregar el
cacao y las gotas de chocolate y mezclar con cui-
dado. Con ayuda de dos cucharas formar porcio-
nes con la masa de merengue y colocarlas sobre
una bandeja de horno engrasada, distribuyéndo-
las homogéneamente. Bajar la temperatura a
160° C y dejar que se sequen aprox. 20 minutos
en el horno. Dejar enfriar.
Pudín de chocolate:
500 ml de nata para batir
50 g de azúcar
5 yemas de huevo

85 g de cobertura oscura de chocolate (mín. 60%)
1 vaina de vainilla
Rajar las vainas de vainilla y poner a calentar en
una cacerola con la nata, el chocolate y el azú-
car. Separar $1/4$ de la nata, mezclar rápidamente
con las yemas de huevo y devolver a la cacerola.
A continuación, calentar la mezcla de las yemas
y la nata hasta que rompa a hervir y dejar cocer
hasta que se espese. Verter en una fuente plana,
cubrir con papel aluminio y enfriar.
Peras escalfadas:
4 peras
400 g de azúcar
500 ml de agua
500 ml de vino de ciruela
3 cucharitas de anís estrellado
Pelar las peras, cortarlas en dos mitades y eliminar
el corazón con las pepitas. Calentar el agua junto
con el azúcar y el anís estrellado hasta que rompa
a hervir. Agregar las peras y el vino de ciruela y
cocer "al dente". Dejar enfriar en la decocción.

Per le meringhe:
3 albumi
200 g di zucchero
225 g di gocce di cioccolato
3 cucchiaiate di cacao
Preriscaldate il forno a 180 °C. Montate gli albu-
mi fino a metà densità, poi unitevi lentamente lo
zucchero continuando a montare gli albumi fino a
neve densa e fino a quando lo zucchero si sarà
sciolto. Aggiungete con delicatezza la polvere di
cacao e le gocce di cioccolato. Con due cucchiai
grandi formate le meringhe appoggiandole omo-
geneamente sulla teglia precedentemente unta.
Abbassate la temperatura a 160 °C e fateli cuo-
cere al forno per circa 20 minuti Fateli raffreddare.
Budino al cioccolato:
500 ml di panna da montare
50 g di zucchero
5 tuorli
85 g di salsa al cioccolato fondente scuro (con-
tenuto di cacao del 60% min.)

1 stecca di vaniglia
Aprite la stecca di vaniglia e fate scaldare in una
pentola la panna, il cioccolato e lo zucchero insie-
me alla vaniglia. Amalgamate rapidamente i tuor-
li con $1/4$ della panna da montare e rimetteteli sul
fuoco. Ora fate bollire il composto tra tuorli e
panna fino a farlo ispessire. Distribuitelo in una
pirofila dal bordo basso, coprite con la carta sta-
gnola e fatelo raffreddare.
Pere sciroppate:
4 pere
400 g di zucchero
500 ml di acqua
500 ml di vino alle prugne
3 cucchiaini di anice stellato
Sbucciate le pere, tagliatele a metà ed eliminate
il torsolo. Fate bollire l'acqua, lo zucchero e l'a-
nice stellato. Aggiungete le pere ed il vino alle
prugne e fatele cuocere al dente. Fate raffredda-
re le pere nel liquido.

Dolce Enoteca e Ristorante

Design: Dodd Mitchell | Owners: Lonnie Moore, Mike Malin,
Adolfo Suaya | Chef: Mirko Paderno

8284 Melrose Ave / Sweetzer Ave | Los Angeles, CA 90046
Phone: +1 323 852 7174
www.dolceenoteca.com
Opening hours: Every day 6 pm to 2 am
Special features: Late night dining, celeb hangout, valet parking
Average price: $ 35
Cuisine: Italian

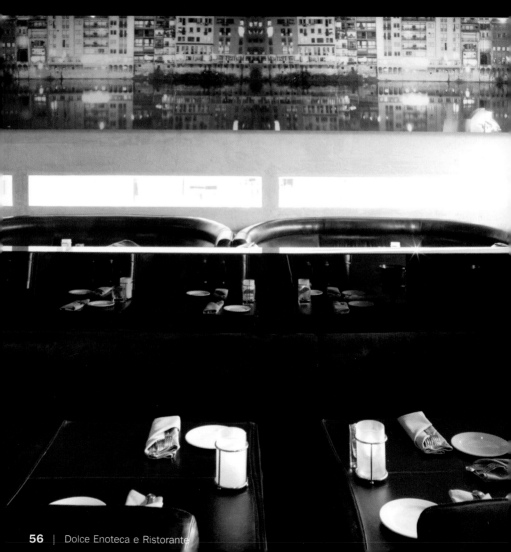

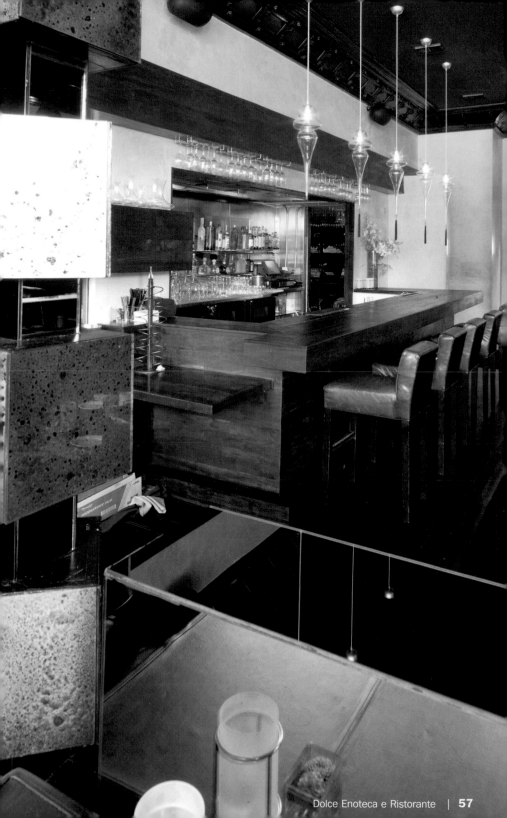

Risotto a la Milanese

with Braised Veal

Risotto nach Milaneser Art
mit geschmorten Kalbsbacken

Risotto à la milanaise
et côtelettes de veau braisées

Risotto al estilo milanés
con carrillos de ternera asados

Risotto alla milanese
con guanciali di vitello stracotti

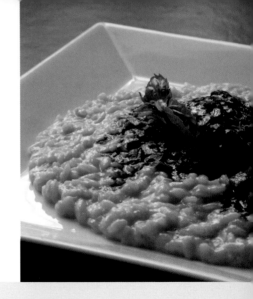

Risotto:
2 tbsp olive oil
2²/3 cup Vealone Nano (risotto rice)
1 large onion
1 cup of white wine
2 l of chicken stock
1 tsp saffron
2/3 cup parmesan cheese, grated
1/2 cup butter
Salt and pepper

Finely chop the onion and sautee with olive oil. Toss rice in and sautee. Add white wine when rice begins to soften. Slowly add chicken stock. Add saffron 15–18 minutes later. Add salt and pepper to taste. Finish risotto with parmesan and butter.

Vealcheeks:
6 veal cheeks
3 tbsp olive oil
1 celery
1 onion
1 carrot
2 tbsp tomato paste
1 cup white wine
Salt and pepper to taste

Sear veal cheeks in olive oil at high temperature on both sides of the veal cheeks. Add finely chopped cubes of celery, onion, and carrot. Put veal in a sheet pan with all ingredients. Braise veal and all ingredients at 350 °F for two hours.

On a plate, place the risotto, then add a cheek of veal to the top. Finish with the juice from the veal.

Risotto:
2 EL Olivenöl
400 g Risottoreis
1 große Zwiebel
250 ml Weißwein
2 l Geflügelbrühe
1 TL Safran
100 g geriebener Parmesan
100 g Butter
Salz und Pfeffer

Die Zwiebel in kleine Würfel schneiden und im Olivenöl anschwitzen. Den Reis hinzufügen und glasig dünsten. Mit dem Weißwein ablöschen und nach und nach unter Rühren die Brühe zugeben. Köcheln lassen bis der Reis weich ist. Den Safran unterrühren und mitgaren. Zum Schluss mit Salz und Pfeffer würzen und mit Butter und Parmesan abschmecken.

Kalbsbacken:
6 Kalbsbacken
Olivenöl
1 Sellerieknolle
1 Zwiebel
1 Karotte
2 EL Tomatenmark
250 ml Weißwein
Salz und Pfeffer

Kalbsbacken von allen Seiten scharf anbraten, gewürfeltes Gemüse zugeben. Alle Zutaten in ein Saftblech für den Backofen geben und bei 180 °C für zwei Stunden schmoren.

Reis und eine Kalbsbacke auf einem Teller anrichten und mit dem Bratensaft nappieren.

Risotto :
2 c. à soupe d'huile d'olive
400 g riz au risotto
1 gros oignons
250 ml de vin blanc
2 l de bouillon de volaille
1 c. à café de safran
100 g de parmesan râpé
100 g de beurre
Sel et poivre

Couper les oignons en dés fins et faire blondir dans l'huile d'olive. Ajouter le riz et faire revenir. Arroser avec le vin blanc puis ajouter peu à peu le bouillon tout en continuant de mélanger. Faire cuire à feu doux jusqu'à ce que le riz soit bien tendre. Ajouter le safran et faire cuire avec le mélange. Saler et poivrer puis assaisonner avec du beurre et du parmesan.

Côtelettes de veau :
6 côtelettes de veau
Huile d'olive
1 céleri-rave
1 d'oignon
1 carotte
2 c. à soupe d'concentré de tomates
250 ml de vin blanc
Sel et poivre

Saisir à point les côtelettes de veau sur tous les côtés puis ajouter les légumes en dé. Verser tous les ingrédients sur une plaque à jus pour le four et braiser à 180 °C pendant deux heures.

Présenter le riz et une côtelette de veau sur une assiette puis napper avec le jus de rôti.

Risotto:
2 cucharadas de aceite de oliva
400 g de arroz para risotto
1 cebolla grande
250 ml de vino blanco
2 l de caldo de ave
1 cucharita de azafrán
100 g de parmesano rallado
100 g de mantequilla
Sal y pimienta

Cortar la cebolla en cuadraditos y freír en el aceite de oliva hasta dorarse. Agregar el arroz y hervirlo hasta que quede vidrioso. Rebajar con el vino blanco y añadir poco a poco el caldo sin dejar de remover. Dejar hervir hasta que el arroz esté hecho. Agregar el azafrán, remover y dejar que siga cociendo. Por último, salpimentar y sazonar con la mantequilla y el queso parmesano.

Carrillos de ternera:
6 carrillos de ternera
Aceite de oliva
1 raíz de apio
1 cebolla
1 zanahoria
2 cucharadas de Concentrado de tomate
250 ml de vino blanco
Sal y pimienta

Freír a fuego fuerte los carrillos por todos los lados y agregar la verdura troceada. Colocar todos los ingredientes en una bandeja de horno profunda y asar durante dos horas a 180 °C.

Aderezar el arroz y un carrillo de ternera en un plato y cubrir con la salsa del asado.

Per il risotto:
2 cucchiai di olio di oliva
400 g di riso da risotto
1 cipolla grande
250 ml di vino bianco
2 l di brodo di gallina
1 cucchiaino di zafferano
100 g di parmigiano grattugiato
100 g di burro
Sale e pepe

Tagliate la cipolla a dadini e fatela appassire nell'olio di oliva. Unitevi il riso e fatelo appassire. Deglassate con il vino bianco ed unitevi, poco alla volta, i mestoli di brodo, continuando a mescolare. Terminate la cottura del risotto a fuoco basso fino a quando il riso sarà pronto. Unite lo zafferano e terminate la cottura. A cottura ultimata aggiustate di sale e pepe ed aggiungete il burro ed il parmigiano grattugiato.

Guanciali di vitello:
6 guanciali di vitello
Olio di oliva
1 radice di sedano
1 cipolla
1 carota
2 cucchiai di concentrato di pomodoro q.b.
250 ml di vino bianco
Sale e pepe

Fate rosolare a fuoco vivace i guanciali da tutte le parti ed aggiungete la verdura tagliata a dadi. Ora mettete il tutto in una casseruola ed al forno e fatelo cuocere per due ore a 180 °C.

Disponete il risotto ed un guanciale sul piatto e nappate con il sughetto della carne.

EM Bistro

Design: Bret Witke | Owner: Charles Nuzzo
Chef: Anne Conness | Pastry Chef: Natasha MacAller

8256 Beverly Blvd / N Sweetzer Ave | Los Angeles, CA 90048
Phone: +1 323 658 6004
Opening hours: Mon–Thu 6 pm to 10 pm, Fri–Sat 6 pm to 11 pm
Average price: $ 35
Cuisine: New and traditional American
Special features: Live jazz, celeb hangout, valet parking

Eurochow

Design: Michael Chow, www.mrchow.com
Chef: Giuseppe Anzelmo

1099 Westwood Blvd / Kinross Ave | Los Angeles, CA 90024
Phone: +1 310 209 0066
www.eurochow.com
Opening hours: Every day 6 pm to 11 pm
Average price: $ 48
Cuisine: Chinese, Italian
Special features: Group dining, valet parking, full bar, wedding, receptions

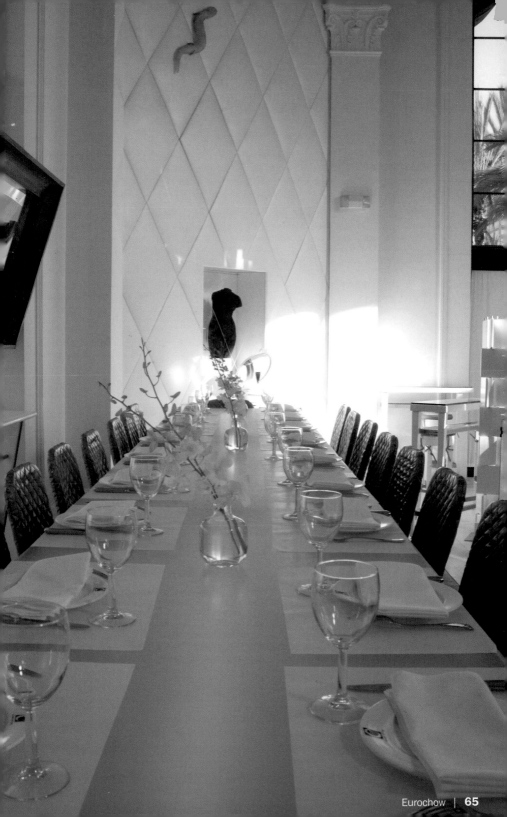

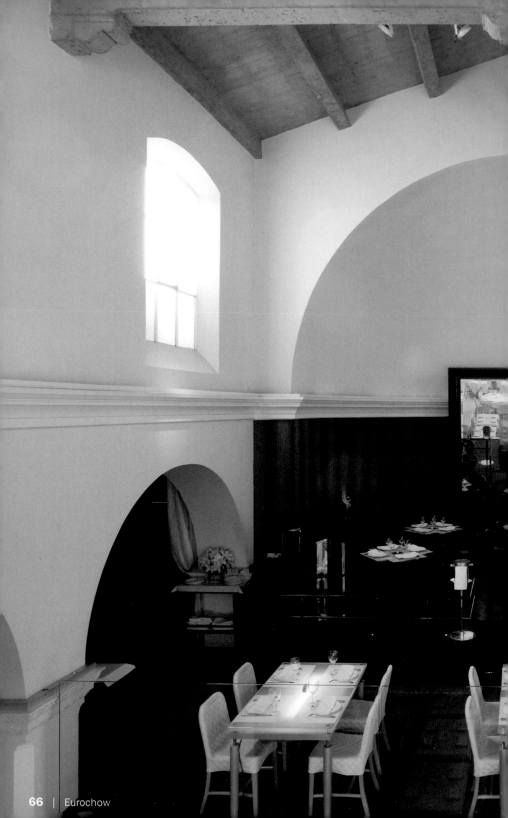

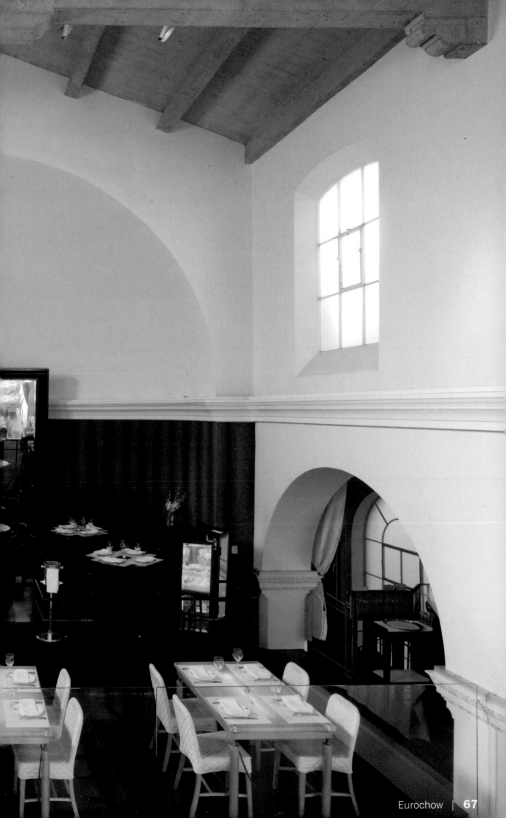

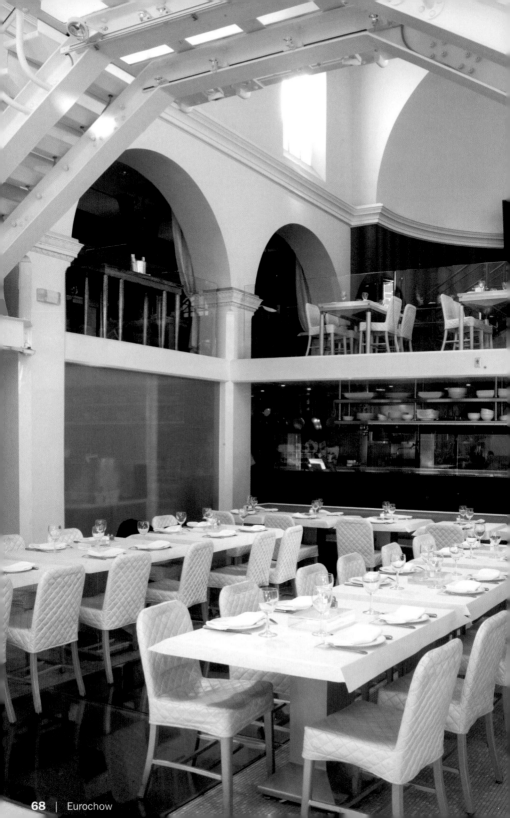

Falcon

Design: John Friedman Alice Kimm Architects, www.jfak.net
Chef: Walter Castillo

7213 Sunset Blvd / Alta Vista Blvd | Hollywood, CA 90046-3405
Phone: +1 323 850 5350
www.falconslair.com
Opening hours: Every day 6 pm to 1:30 am
Average price: $ 48
Cuisine: New American
Special features: Late night dining, celeb hangout, valet parking

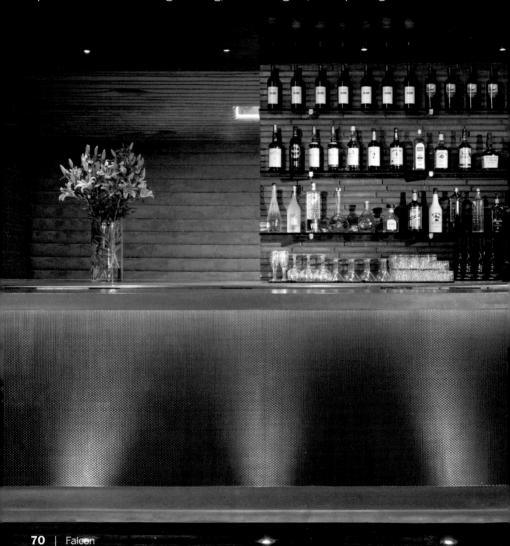

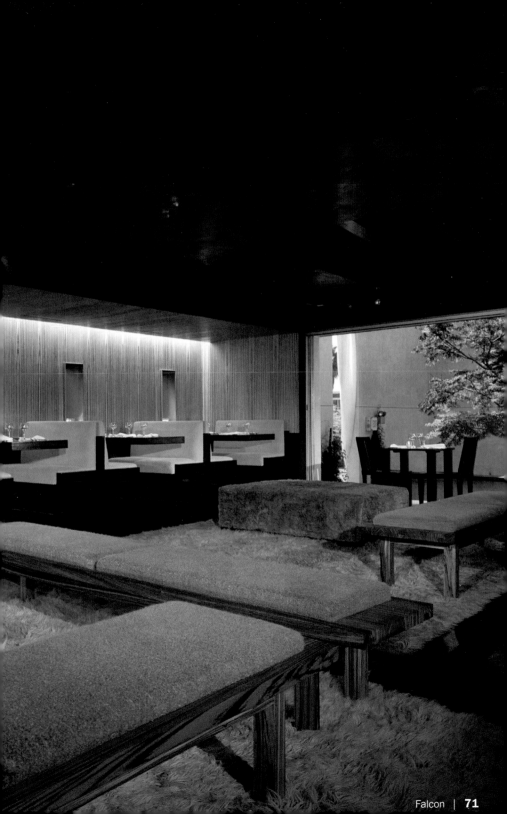

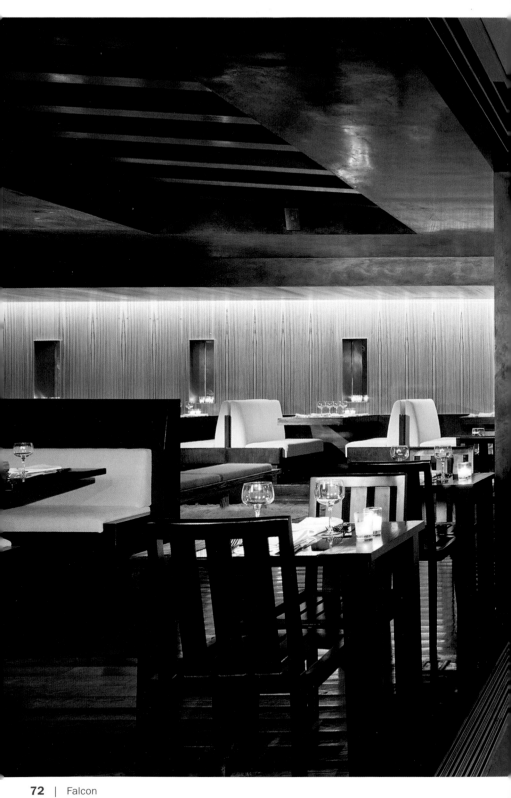

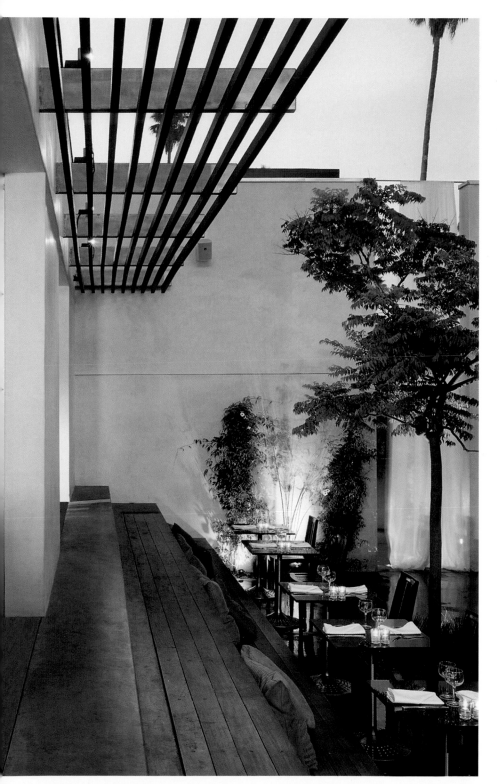

Lobster Chopper Salad

„Chopper" Hummersalat
Salade de homard « Chopper »
Ensalada de langosta "Chopper"
Insalata di arragosta alla "Chopper"

3 oz lobster (can be from claw or tail / poached or steamed)
4 oz butter lettuce
2 oz diced fresh avocado
2 oz smoked bacon, sauted in extra virgin olive oil until crispy then diced in small pieces
1 oz white corn (grilled or steamed)
1 oz microgreens mixture (young lettuce, seedlings)
2 tbsp buttermilk dressing

Buttermilk Dressing:
1 cup sour cream or crème fraîche
2 tbsp buttermilk
1 red onion (finely diced)
1 tsp honey
Salt and pepper to taste
Mix all ingredients together and puree.

Cut all ingredients in bite-size pieces and combine in a bowl. Toss with dressing.

90 g gegartes Hummerfleisch
120 g Salatherzen
60 g Avocado in Würfeln
60 g Räucherspeck (in Olivenöl knusprig gebraten und in kleine Stücke geschnitten)
30 g Mais (gegrillt oder gedämpft)
30 g junger Salat (Setzlinge)
2 EL Buttermilchvinaigrette

Buttermilchvinaigrette:
250 ml Saure Sahne od. Crème fraîche
2 EL Buttermilch
1 rote Zwiebel (fein gewürfelt)
1 TL Honig
Salz und Pfeffer
Alle Zutaten miteinander pürieren.

Alle Zutaten in mundgerechte Stücke zerteilen, in eine Schüssel geben und mischen.
Mit der Buttermilchvinaigrette anmachen und abschmecken.

90 g de chair de homard cuite
120 g de cœurs de salade
60 g d'avocat en cube
60 g de lardons (rôtis croustillants dans l'huile
d'olive et coupés en petits morceaux)
30 g de maïs (grillé ou cuit à la vapeur)
30 g de salade jeune (plants)
2 c. à soupe de vinaigrette au babeurre

Vinaigrette au babeurre :
250 ml de crème aigre ou de crème fraîche
2 c. à soupe de babeurre
1 oignon rouge (en dés fins)
1 c. à café de miel
Sel et poivre
Mélanger tous les ingrédients et réduire en purée.

Couper tous les ingrédients en morceaux agréables au goût, verser dans un saladier et mélanger. Préparer avec la vinaigrette au babeurre et assaisonner.

90 g de carne de langosta cocida
120 g de corazones de lechuga
60 g de aguacate cortado en cuadraditos
60 g de tocino ahumado (frito en aceite de oliva
hasta quedar crujiente y cortado en trocitos)
30 g de maíz (asado o hervido al vapor)
30 g de lechuga tierna (plantones)
2 cucharadas de vinagreta de suero de leche

Vinagreta de suero de leche:
250 ml de nata ácida o crème fraîche
2 cucharadas de suero de leche
1 cebolla roja (picada finamente)
1 cucharadita de miel
Sal y pimienta
Pasar todos los ingredientes por el pasapuré.

Cortar todos los ingredientes en trozos pequeños, introducir en una fuente y mezclar. Aderezar con la vinagreta de suero de leche y sazonar.

90 g di carne di arragosta bollita
120 g di cuori di insalata
60 g di avocado tagliato a dadi
60 g di pancetta affumicata (fatta saltare nell'olio di oliva fino a farla diventare croccante e tagliata a pezzettini)
30 g di mais (cotto a vapore o alla griglia)
30 g di insalatina
2 cucchiai di vinaigrette al latticello

Vinaigrette al latticello:
250 ml di panna acida oppure crème fraîche
2 cucchiai di latte battuto
1 cipolla rossa (tagliata a dadini)
1 cucchiaino di miele
Sale e pepe
Fate frullare insieme tutti gli ingredienti.

Dividete tutti gli ingredienti a bocconcini, adagiateli in una scodella e mescolate. Aggiungete la vinaigrette al latticello ed aggiustate.

Grace

Design: Michael Berman | Chef: Neal Fraser

7360 Beverly Blvd | Los Angeles, CA 90036
Phone: +1 323 934 4400
www.gracerestaurant.com
Opening hours: Dinner Tue–Thu, Sun 6 pm to 10 pm, Fri–Sat 6 pm to 11 pm
Special features: Celeb hangout, valet parking
Average price: $ 48
Cuisine: New American

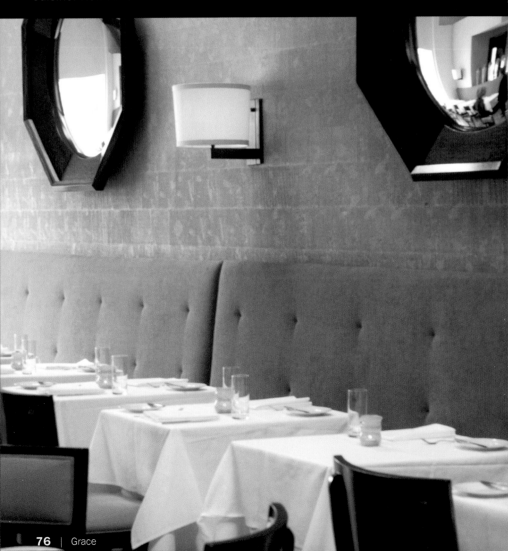

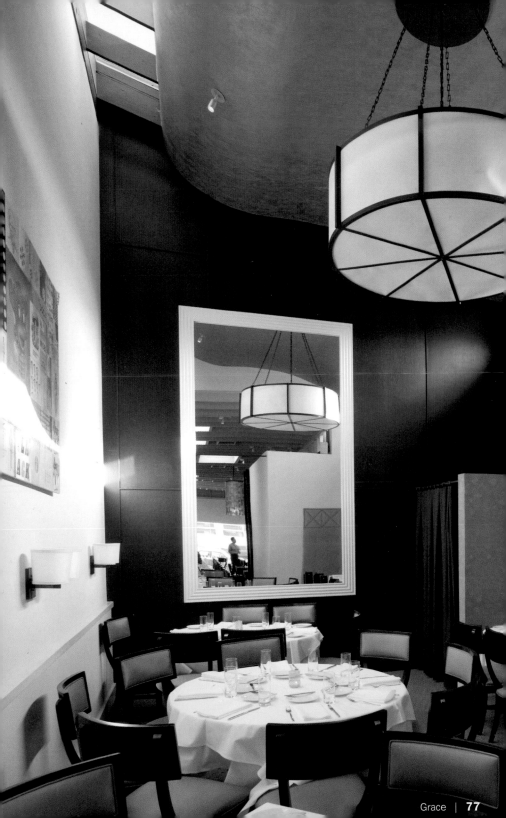

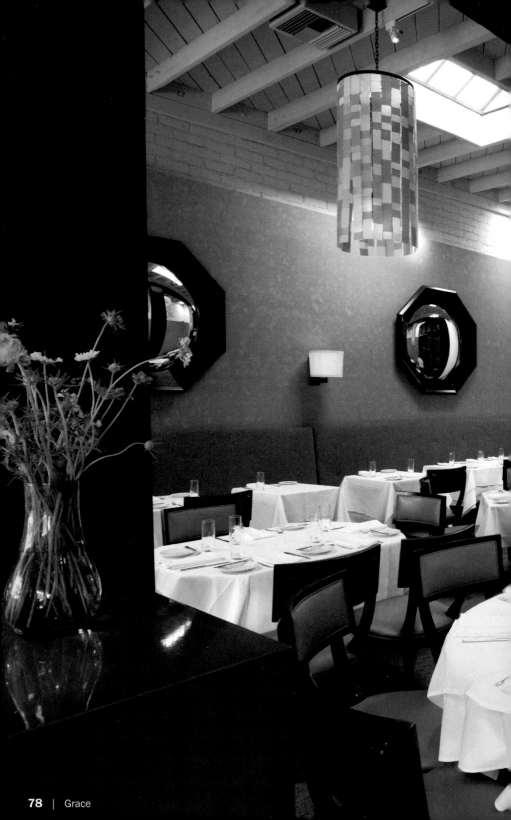

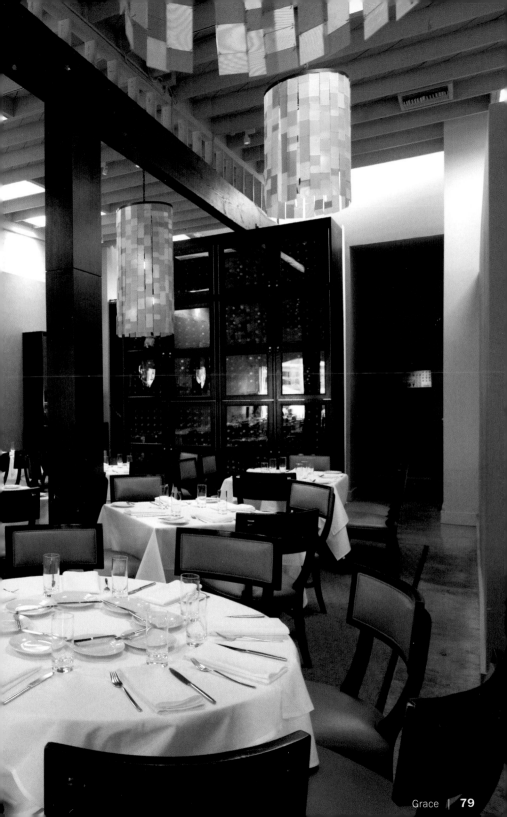

Dungeness Crab Salad

Dungeness Krabbensalat
Salade de crabe Dungeness
Ensalada de gambas Dungeness
Insalata di granchi alla Dungeness

Lemon syrup:
1 cup lemon juice
1 cup sugar
Reduce lemon juice and sugar to a sauce consistency (by half); you will have more base than you need for this recipe.

Lemon vinaigrette:
2 lemons, squeezed and juiced
4 oz grapeseed oil
4 oz lemon syrup
Rice wine vinegar
Combine the lemon syrup and the grapeseed oil with the lemon juice. Add the rice wine vinegar to taste and balance with more oil if necessary.

Basil oil:
3 oz basil
3 oz grapeseed oil
Salt to taste

Blanch basil in boiling salted water and shock in ice water. Wring out water. In a blender, combine basil and grapeseed oil until puréed and add a touch of salt. Put purée in a stainless steel sauce pot, bring to a boil and strain through a cheese cloth or chinois. Funnel the basil oil into a squirt bottle.

Salad:
8 oz Dungeness crab meat
2 oz frozen green peas, thawed
1/4 oz mint, julienne
1/4 oz thai basil, julienne
1 oz microgreens (young lettuce, seedlings)
Salt and pepper to taste
Combine dry ingredients except micro greens and lightly toss with vinaigrette. Season with salt and pepper to taste. Pack this mixture down into a ring mold, then remove the ring. Sprinkle top with micro greens and garnish bowl with more of the vinaigrette and garnish with the basil oil.

Zitronensirup:
250 ml Zitronensaft
200 g Zucker
Zitronensaft und Zucker mischen und auf die Hälfte einreduzieren lassen (ergibt mehr als man für ein Rezept braucht).

Zitronenvinaigrette:
Saft von 2 Zitronen
4 EL Traubenkernöl
4 EL Zitronensirup
Reisessig
Den Zitronensaft, das Öl und den Zitronensirup mischen und je nach Säure der Zitronen mit dem Essig abschmecken.

Basilikumöl:
90 g Basilikumblätter
90 ml Traubenkernöl
Salz zum Abschmecken

Basilikum in Salzwasser blanchieren, abschrecken und das Wasser ausdrücken. Die Blätter und das Öl in einem Mixer pürieren und abschmecken. Das Püree erhitzen und durch ein Tuch abseihen. In eine Flasche umfüllen.

Salat:
230 g Krebsfleisch
60 g Erbsen
1 TL Minze in Streifen
1 TL Basilikumstreifen
30 g junge Salatsetzlinge
Salz und Pfeffer
Trockene Zutaten miteinander mischen (außer Salat), und mit der Vinaigrette marinieren. Abschmecken. Die Masse in einem Metallring in Form drücken, mit dem Gemüse verzieren und die restliche Vinaigrette sowie das Basilikumöl darüber verteilen.

Sirop de citron :
250 ml de jus de citron
200 g de sucre
Mélanger le citron et le sucre et faire réduire à la
moitié (on obtient plus que ce dont on a besoin
pour une seule recette).

Vinaigrette au citron :
Jus de 2 citrons
4 c. à soupe d'huile de pépins de raisin
4 c. à soupe de sirop de citron
Vinaigre de riz
Mélanger le jus de citron, l'huile et le sirop de
citron puis assaisonner au vinaigre en fonction de
l'acidité des citrons.

Huile de basilic :
90 g de feuilles de basilic
90 ml d'huile de pépins de raisin
Du sel pour assaisonner

Faire blanchir le basilic dans de l'eau salée, trem-
per dans l'eau froide et égoutter. Réduire les feuil-
les et l'huile en purée dans un mixeur et assai-
sonner. Réchauffer la purée et filtrer dans un tor-
chon. Verser dans une bouteille.

Salade :
230 g de chair de crabe
60 g de petits poix
1 c. à café de menthe en lamelles
1 c. à café de basilic en lamelles
30 g de plants de salade jeune
Sel et poivre
Mélanger les ingrédients secs (à l'exception de la
salade), faire mariner avec la vinaigrette. Mettre
la masse en forme dans un anneau métallique,
garnir avec les légumes puis répartir le reste de la
vinaigrette ainsi que l'huile de basilic.

Jarabe de limón:
250 ml de zumo de limón
200 g de azúcar
Mezclar el zumo de limón y el azúcar y reducir a
la mitad (la cantidad resultante es más que sufi-
ciente para una receta).

Vinagreta de limón:
Zumo de 2 limones
4 cucharadas de aceite de semilla de uva
4 cucharadas de jarabe de limón
Vinagre de arroz
Mezclar el zumo de limón, el aceite y el jarabe de
limón y sazonar con el vinagre dependiendo del
grado de acidez del limón.

Aceite de ajedrea:
90 g de hojas de ajedrea
90 ml de aceite de semilla de uva
Sal para sazonar

Escaldar la ajedrea en agua salada, pasarla por
agua fría y exprimir el agua restante. Triturar las
hojas y el aceite con el pasapuré y sazonar.
Calentar el puré y colar por un paño. Verter en
una botella.

Ensalada:
230 g de carne de cangrejo
60 g de guisantes
1 cucharadita de menta en tiras finas
1 cucharadita de ajedrea en tiras finas
30 g de lechuga tierna (plantones)
Sal y pimienta
Mezclar los ingredientes secos (excepto la lechu-
ga) y marinar con la vinagreta. Sazonar. Introducir
la masa en un anillo de metal para darle forma,
decorar con la verdura y esparcir el resto de la
vinagreta y el aceite de ajedrea encima.

Sciroppo ai limoni:
250 ml di succo di limone
200 g di zucchero
Mescolate il succo di limone con lo zucchero e
fatelo ridurre a metà (ne risulta una quantità
maggiore a quanto necessita la ricetta).

Vinaigrette ai limoni:
Il succo di due limoni
4 cucchiai di olio di vinaccioli
4 cucchiai di sciroppo ai limoni
Aceto di riso
Mescolate il succo dei limoni, l'olio e lo sciroppo
ai limoni ed aggiustate con l'aceto, a secondo
dell'acidità dei limoni.

Olio al basilico:
90 g di foglie di basilico
90 ml di olio di vinaccioli
Sale q.b.

Lessate brevemente il basilico in acqua salata,
passatelo sotto l'acqua fredda ed eliminate l'ac-
qua schiacciandolo. Fate frullare le foglie e l'olio
nel mixer ed aggiustate. Ora scaldate il puree e
fatelo passare da uno strofinaccio. Versate ques-
t'olio in bottiglie.

Insalata:
230 g di carne di granchio
60 g di piselli
1 cucchiaino di menta tagliata a strisce
1 cucchiaino di basilico tagliato a strisce
30 g di insalatina
Sale e pepe
Mescolate gli ingredienti asciutti (tranne l'insala-
tina) e fateli marinare con la vinaigrette, aggiu-
state. Versate l'impasto in uno stampo rotondo,
rovesciatelo e decorate con l'insalatina e nappa-
te con la rimanente vinaigrette e l'olio al basilico.

Katana

Design: Dodd Mitchell | Chef: Vernon Cardenas

8439 W Sunset Blvd / La Cienega Blvd | West Hollywood, CA 90069
Phone: +1 323 650 8585
www.katanarobata.com
Opening hours: Sun–Thu 5:30 pm to 1 am, Fri–Sat 5:30 pm to 2 am
Average price: $ 35
Cuisine: Japanese, Robatayaki, sushi
Special features: Late dining, private rooms, outdoor dining,
celeb hangout, valet parking

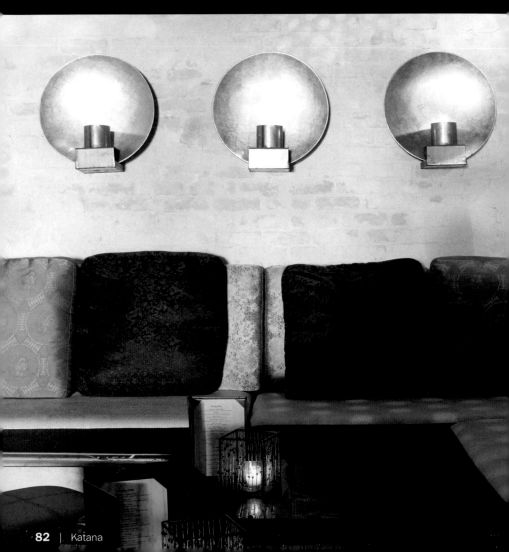

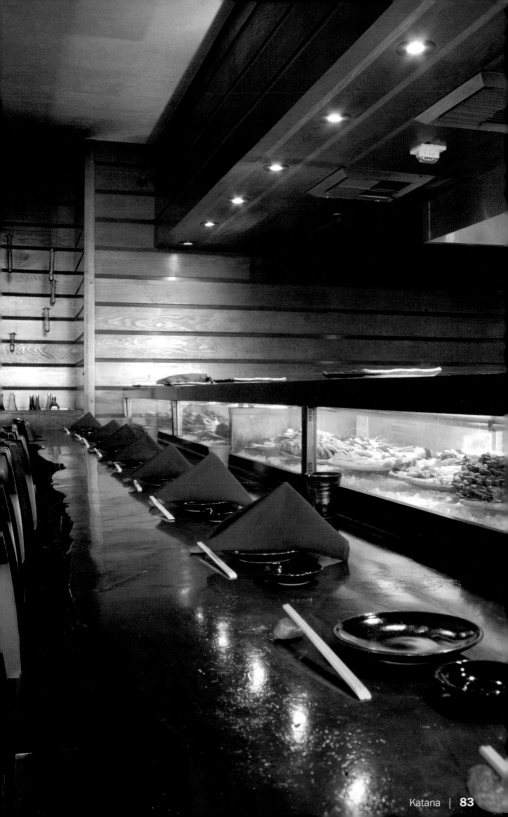

Backed

Alaskan Black Cod

Gebackener Alaska-Kabeljau
Cabillau d'Alaska cuit au four
Bacalao de Alasca asado
Merluzzo bianco dell'Alaska fritto

1/2 cup Saikyo (sweet) miso paste
1 cup Shiro (white) miso paste
1/4 cup "Hancho"(dark) miso paste
1/2 cup sugar
1/4 cup sake (Japanese rice wine)
1/4 cup Mirin (sweet cooking sake)
1 lb Alaskan black cod filet
(cleaned and cut into 4 pieces)

Place all ingredients (excluding fish) into mixing bowl and stir evenly until silky consistency. Place the cod filet in the marinade and leave for approximately five to seven hours at the minimum and refrigerate. Thereafter, before placing on a lightly greased cookie sheet, rinse the miso marinee off the filets. Place cod in oven (preheated at 375 °F) and bake for approximately 10–12 minutes (not necessary to turn over during cooking).

100 g Saikyo Miso Paste (süß)
200 g Shiro Miso Paste (weiß)
50 g Hancho Miso Paste (dunkel)
100 g Zucker
60 ml Sake (Reiswein)
60 ml Mirin (süße Sake)
500 g Alaska Kabeljau
(gesäubert und in 4 Teilen)

Alle Zutaten (außer dem Fisch) in einen Schüssel miteinander mischen bis sich eine seidige Konsistenz ergibt. Den Fisch in dieser Marinade einlegen und für ca. fünf bis sieben Stunden im Kühlschrank marinieren lassen. Vor dem Garen den Fisch abspülen und auf einem leicht gefetteten Blech im vorgeheizten Backofen bei 190 °C 10–12 Minuten backen (muss nicht umgedreht werden).

100 g de pâte Saikyo miso (sucré)
200 g de pâte Shiro miso (blanc)
50 g de pâte Hancho miso (foncé)
100 g de sucre
60 ml de saké (vin de riz)
60 ml de mirin (saké sucré)
500 g de cabillau d'Alaska
(Nettoyé et coupé en quatre portions)

Mélanger tous les ingrédients (à l'exception du poisson) dans un saladier jusqu'à obtention d'un mélange satiné. Déposer le poisson dans cette marinade et faîtes macérer pour environ cinq à sept heures dans le réfrigérateur. Avant la cuisson, laver le poisson et faire cuire sur une plaque légèrement graissée dans le four préchauffé à 190 °C pendant 10 à 12 minutes (il n'est pas nécessaire de le retourner).

100 g de pasta miso Saikyo (dulce)
200 g de pasta miso Shiro (clara)
50 g de pasta miso Hancho (oscura)
100 g de azúcar
60 ml de sake (vino de arroz)
60 ml de mirin (sake dulce)
500 g de bacalao de Alasca
(limpio y cortado en 4 trozos)

Mezclar todos los ingredientes (excepto el pescado) en una fuente hasta que la mezcla obtenga una consistencia sedosa. Colocar el pescado en este escabeche y dejar reposar durante aprox. cinco o siete horas en el frigorífico. Antes de cocinarlo, enjuagar el pescado y colocarlo luego en una bandeja untada con algo de aceite. Asar en el horno precalentado a 190 °C durante 10–12 minutos (no hay que darle la vuelta).

100 g di salsa saikyo miso (dolce)
200 g di salsa shiro miso (bianca)
50 g di salsa hancho miso (scura)
100 g di zucchero
60 ml di sake (vino di riso)
60 ml di mirin (sake dolce)
500 g di merluzzo bianco dell'Alaska
(pulito e tagliato a 4 pezzi)

Amalgamate tutti gli ingredienti (tranne il pesce) in una scodella fino a quando avrete ottenuto una consistenza setosa. Fate marinare il pesce in questa marinata per circa cinque o sette ore nel frigorifero. Sciaquate il pesce e fatelo cuocere per circa 10–12 minuti a 190 °C nel forno preriscaldato, adagiandolo su una teglia leggermente unta (il pesce non va girato).

Koi

Design: Thomas Schoos, www.schoos.com
Chef: Rob Lucas, Nicholas Bovine

730 N La Cienega Blvd / Melrose Place | West Hollywood, CA 90069
Phone: +1 310 659 9449
Opening hours: Mon–Fri 11:30 am to 2:30 pm, 6:30 pm to close
Sat–Sun 6:30 pm to 11 pm
Average price: $ 48
Cuisine: Sushi, Japanese inspired with Californian accents
Special features: Outdoor dining, celeb hangout, valet parking

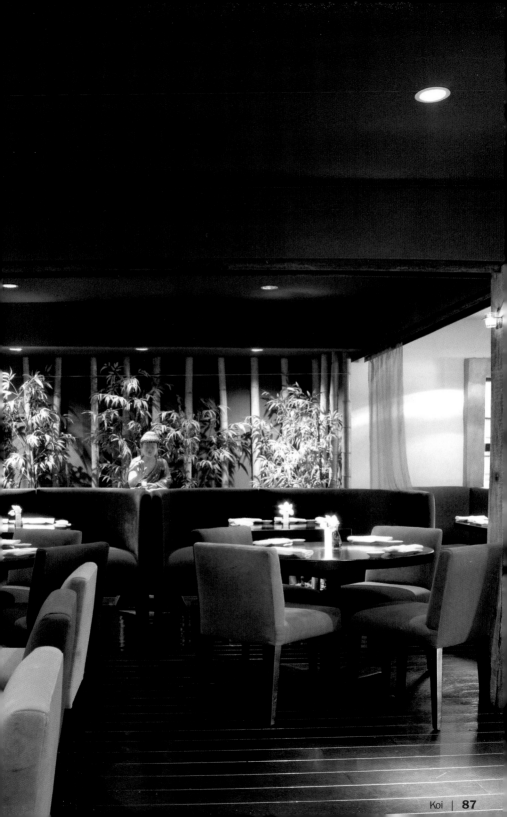

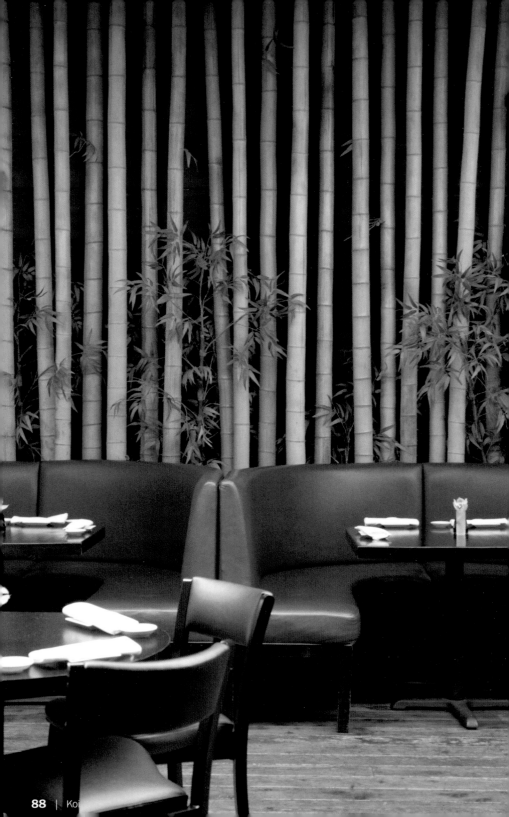

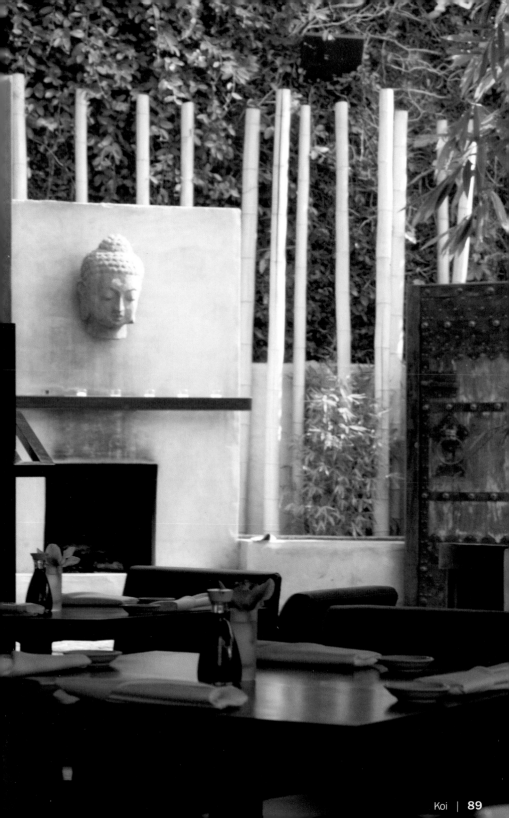

Seared
Ahi Tuna
with Japanese Salsa

Gebratener Ahi Thunfisch
mit japanischer Salsa
Thon Ahi rôti et sa sauce japonaise
Atún Ahi frito con salsa japonesa
Tonno Ahi arrosto con salsa giapponese

4 oz Ahi tuna steak, sashimi grade
1 tsp ground garlic
Salt and pepper
Olive oil
2 oz sake
1/2 tbsp soy sauce

Rub garlic on both sides of tuna, season with salt and pepper. In a skillet heat oil over medium to high heat, sear both sides of tuna quickly, deglaze with sake and then turn off heat and splash with soy sauce turning tuna to cover all sides, set aside.

Salsa:
2 oz of pre-made or store bought ponzu (a Japanese citrus vinegar)
1 tsp oil
1 cup finely chopped tomatoes
1 stock minced scallion
1 tsp chopped cilantro
Mix together

Slice tuna against the grain and shingle on a plate, spoon salsa on each side of tuna, garnish and serve. Sliced avocado and gobo (pickled burdock root) as garnish.

120 g Ahi Thunfischsteak
(„Sashimi" Sushi Qualität)
1 TL gemahlener Knoblauch
Salz und Pfeffer
Olivenöl
2 EL Sake
1/2 EL Sojasauce

Den Fisch von beiden Seiten mit Knoblauch einreiben, salzen und pfeffern. Olivenöl in einer Pfanne erhitzen und den Fisch von beiden Seiten scharf anbraten und mit der Sake bestreichen. Den Herd ausschalten und den Fisch mit der Sojasauce ablöschen, so dass er rundum bedeckt ist. Zur Seite stellen.

Salsa:
2 EL vorgefertigten oder gekauften Ponzu (Japanischer Zitronenessig)
1 TL Öl
200 g Tomaten in kleinen Würfeln
1 Bund junger Lauch, geschnitten
1 TL gehackter Cilantro (chinesischer Koriander)
Alles miteinander mischen.

Den Thunfisch gegen die Maserung aufschneiden und auf einem Teller verteilen, die Salsa daneben geben und mit Avocadoschnitzen und Gobo (eingelegte karottenähnliche Wurzel) garnieren.

120 g steak de thon Ahi
(Qualité Sushi « sashimi »)
1 c. à café d'ail haché
Sel et poivre
Huile d'olive
2 c. à soupe de saké
1/2 c. à soupe de sauce de soja

Frotter le poisson à l'ail des deux côtés, saler et poivrer. Faire chauffer de l'huile d'olive dans une poêle et saisir bien cuit le poisson des deux côtés puis badigeonner avec le saké. Eteindre le four et arroser le poisson avec la sauce de soja, de sorte qu'il soit complètement recouvert. Mettre de côté.

Sauce :
2 c. à soupe de ponzu préparé ou acheté
(vinaigre de citron japonais)
1 c. à café d'huile
200 g de tomate en petits cubes
1 botte de jeune poireau, coupé
1 c. à café de cilantro haché (coriandre chinois)
Mélanger le tout.

Entailler le thon contre la veinure et répartir sur une assiette, verser la sauce à côté et garnir de tranches d'avocat et de gobo (tubercule confit similaire à la carotte).

120 g de filete de atún Ahi
(calidad sushi "sashimi")
1 cucharadita de ajo picado
Sal y pimienta
Aceite de oliva
2 cucharadas de sake
1/2 cucharada de salsa de soja

Restregar el pescado por ambos lados con el ajo, salpimentar. Calentar el aceite de oliva en una sartén y freír el pescado por ambos lados a fuego fuerte y cubrir con el sake. Apagar el fuego y rebajar con la salsa de soja, de forma que el pescado quede completamente cubierto. Colocar a un lado.

Salsa:
2 cucharadas de ponzu preparado o comprado
(vinagre de limón japonés)
1 cucharadita de aceite
200 g de tomates cortados en cuadraditos
1 manojo de puerros tiernos, cortados
1 cucharadita de cilantro picado (cilantro chino)
Mezclar todo.

Cortar el atún en sentido contrario a las vetas y distribuir en un plato, añadir la salsa en un lado y aderezar con las lonchas de aguacate y el gobo (raíz marinada similar a la zanahoria).

120 g di bistecche di tonno ahi
(di qualità "sashimi" sushi)
1 cucchiaino di aglio tritato
Sale e pepe
Olio di oliva
2 cucchiai di sake
1/2 cucchiaio di salsa di soia

Strofinate il pesce da entrambi i lati con l'aglio, salate e pepate. Fate scaldare l'olio di oliva in padella e fate rosolare il pesce da entrambi i lati a fuoco molto vivace e spalmatelo di sake. Ora spegnete il fuoco e deglassate con la salsa di soia in modo da coprire il pesce completamente. Mettetelo da parte.

Per la salsa:
2 cucchiai di ponzu preparato o comperato
(aceto ai limoni giapponese)
1 cucchiaino di olio
200 g di pomodori tagliati a dadini
1 mazzo di porro giovane, tagliato
1 cucchiaino di cilantro macinato (coriandolo cinese)
Mescolate tutti gli ingredienti.

Tagliate il tonno contro il senso della venatura e disponetelo su un piatto, versate la salsa accanto al pesce e guarnite con spicchi di avocado e gobo (un tubero simile alla carota e marinato).

Lucques

Design: Barbara Barry
Owners: Suzanne Goin, Caroline Styne | Chef: Suzanne Goin

8474 Melrose Ave / La Cienega Boulevard | West Hollywood, CA 90069
Phone: +1 323 655 6277
www.lucques.com
Opening hours: Mon 6 pm to 12 midnight,
Tue–Sat 12 noon to 2:30 pm, 6 pm to 12 midnight, Sun 5:30 pm to 10 pm
Average price: $ 48
Special features: Outdoor dining, special occasion dining, valet parking

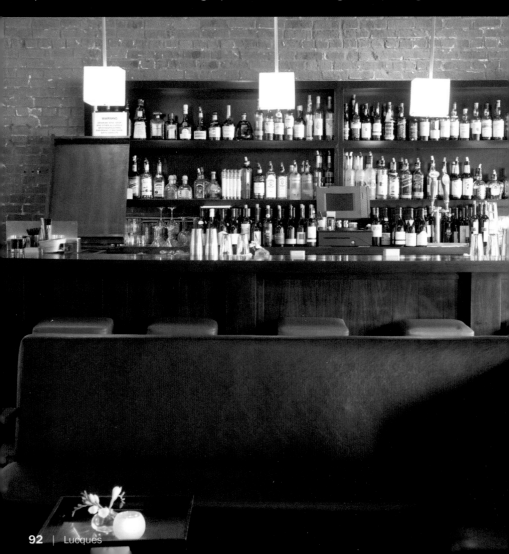

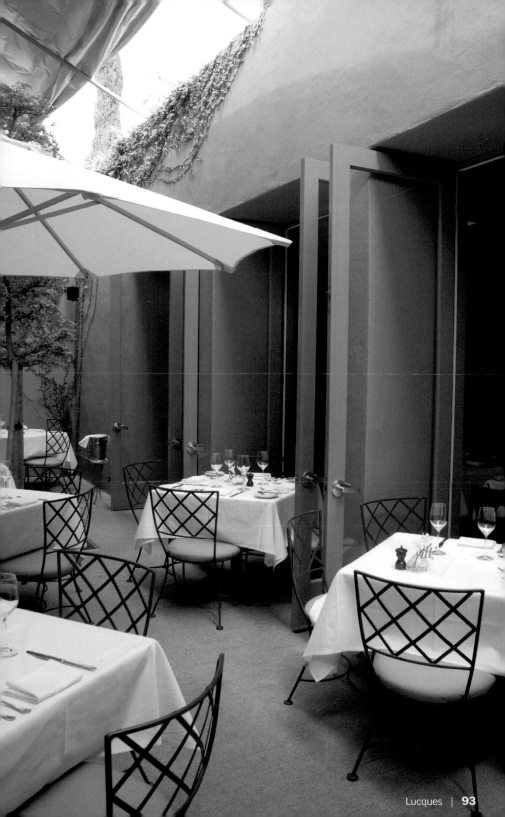

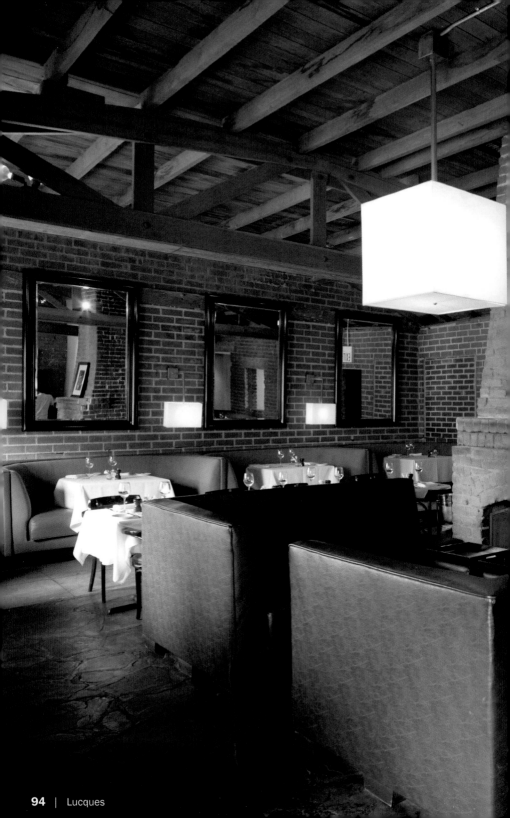

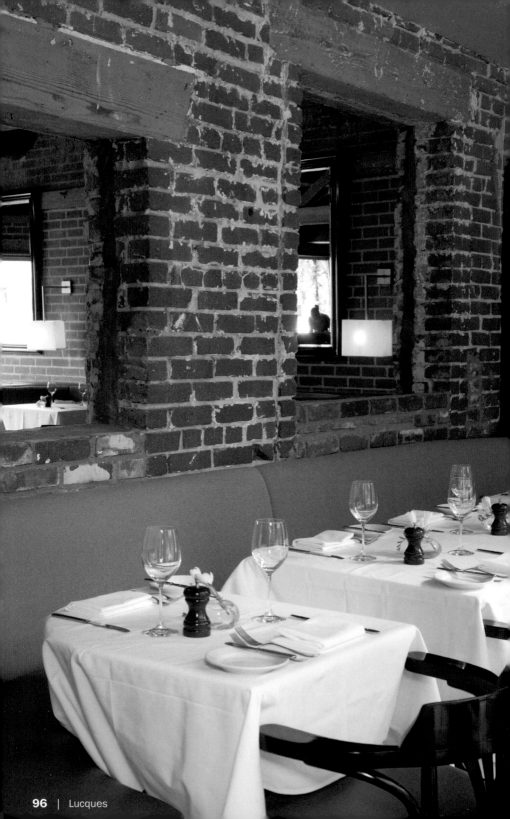

Lucques
Jasmine & Normandy

Lucques Jasmine:
9 cl gin
3 cl cointreau
3 cl campari
A splash of lemon juice
Cool all ingredients and mix in a cocktail-shaker.
Shake well. Chill glases in a freezer.
Pour drink into glases and serve immediatly.

Lucques Normandy:
9 cl "Bombay Sapphire Gin"
3 cl chambord
3 cl fresh lime juice, sugar (sirup)
Cool all ingredients and mix in a cocktail-shaker.
Sweeten for taste. Chill glases in a freezer.
Pour drink into glases and serve immediatly.

Lucques Jasmine:
9 cl Gin
3 cl Cointreau
3 cl Campari
1 Spitzer Zitronensaft
Alle Zutaten gut kühlen und in einem Shaker kräftig mischen. Gläser im Froster eisen.
Gläser befüllen und sofort servieren.

Lucques Normandy:
9 cl „Bombay Sapphire Gin"
3 cl Chambord
3 cl frischen Limonensaft, Zucker (Sirup)
Alle Zutaten gut kühlen und in einem Shaker mischen. Mit Zucker nach Geschmack süßen.
Gläser im Froster eisen.
Gläser befüllen und sofort servieren.

Lucques Jasmine :
9 cl de Gin
3 cl de Cointreau
3 cl de Campari
1 peu de jus de citron
Bien refroidir tous les ingrédients et les mélanger énergiquement dans un shaker. Mettre les verres à glacer dans le fraser. Remplir les verres et servir immédiatement.

Lucques Normandy :
9 cl de « Bombay Sapphire Gin »
3 cl de Chambord
3 cl de jus de lime, sucre (sirop)
Bien refroidir tous les ingrédients et les mélanger dans un shaker. Sucrer suivant les goûts avec le sucre. Mettre les verres à glacer dans le fraser. Remplir les verres et servir immédiatement.

Jasmine de Lucques:
9 cl de ginebra
3 cl de Cointreau
3 cl de Campari
1 chorrito de zumo de limón
Enfriar bien todos los ingredientes y agitar en una coctelera hasta que queden bien mezclados. Refrigerar los vasos en el congelador. Llenar los vasos y servir inmediatamente.

Lucques Normandy:
9 cl de ginebra "Bombay Sapphire"
3 cl de Chambord
3 cl de zumo de lima, Azúcar (jarabe)
Enfriar bien todos los ingredientes y mezclar en la coctelera. Endulzar con azúcar al gusto. Refrigerar los vasos en el congelador. Llenar los vasos y servir inmediatamente.

Lucques Jasmine:
9 cl di gin
3 cl di cointreau
3 cl di campari
1 schizzo di succo di limone
Fate raffreddare tutti gli ingredienti e mescolateli bene nello shaker. Inserite i bicchieri vuoti nel freezer, in modo da farli ghiacciare in superficie. Ora versate il cocktail nei bicchieri e servite immediatamente.

Lucques Normandy:
9 cl di "Bombay Sapphire Gin"
3 cl di chambord
3 cl di succo di limoni, zucchero (sciroppato)
Fate raffreddare tutti gli ingredienti e mescolateli bene nello shaker. Aggiustate di zucchero a piacere. Inserite i bicchieri nel freezer, in modo da farli ghiacciare in superficie. Ora versate il cocktail nei bicchieri e servite immediatamente.

Michael's

Owner: Michael McCarty
Chef: Olivier Rousselle

1147 Third Street | Santa Monica, CA 90403
Phone: +1 310 451 0843
www.michaelssantamonica.com
Opening hours: Mon–Fri 12 noon to 2:30 pm, 6 pm to 10:30 pm,
Sat 5:30 pm to 10:30 pm
Average price: $ 40
Cuisine: Californian, French
Special features: Private parties, outdoor dining, celeb hangout, valet parking

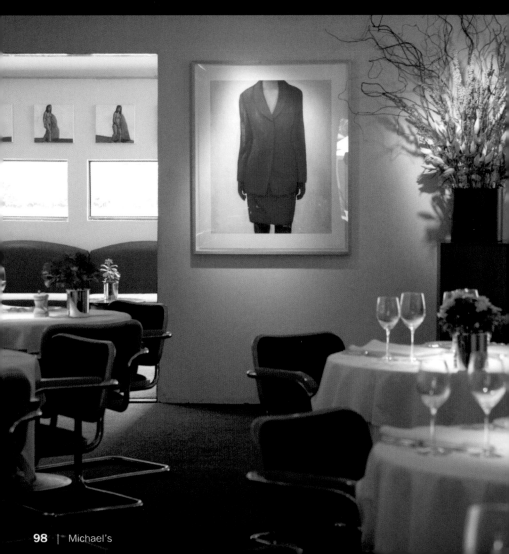

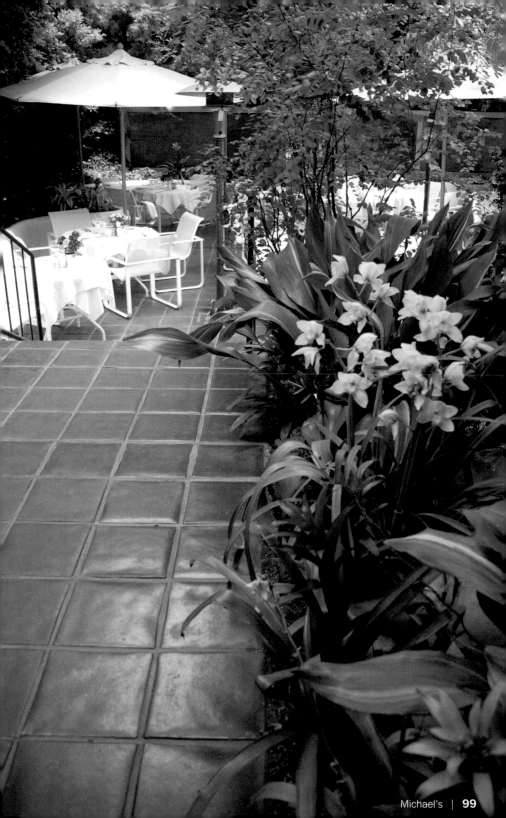

Minibar

Design: Ravel Centeno-Rodriguez, Rebekah Barrow,
Christine Horbach | Chef: Noah Rosen

3413 Cahuenga Blvd W | Los Angeles, CA 90068
Phone: +1 323 882 6965
www.minibarlounge.com
Opening hours: Sun–Thu 5:30 pm to 12 midnight, Fri–Sat 3 pm to 2 am
Average price: $ 25
Cuisine: Global tapas
Special features: Late night dining, private rooms, outdoor dining, valet parking

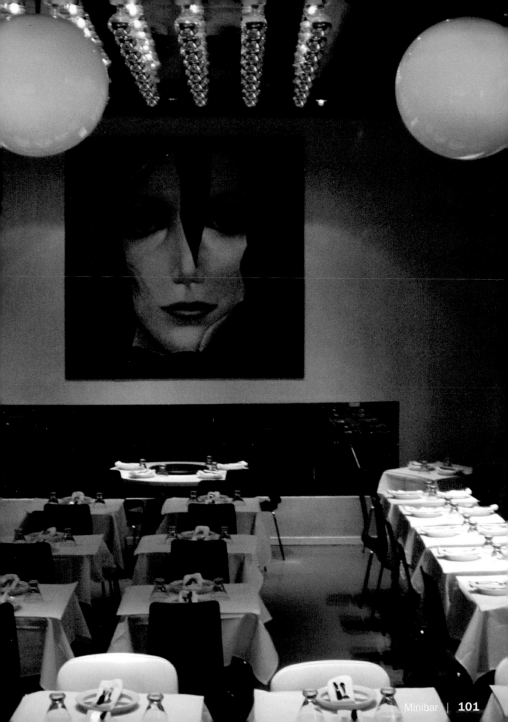

Flatiron Steak Roll

Flatiron Steakroulade
Paupiette de steak Flatiron
Bistec Flatiron relleno
Involtino di bistecca flatiron

2 lbs flatiron steak (special cut from the shoulder)
120 ml beer
1 red onion
1/2 bunch of cilantro (Chinese parsley)
1 jalepeno pepper
Pinch ground cumin
2 tbsp Huitlacoche (corn-truffle, canned)
6 oz cotija cheese (mix of goat cheese and parmesan)

Combine first seven ingredients and marinade for at least two hours. Remove steak from marinade. Heat sauté pan with oil and saute marinated onions. Slice steak about 1/8 inch thick. Roll sautéed onions and cheese in steak and cut each roll in half, then skewer each half. Heat sauté pan with oil. Season rolls with salt and pepper. Sear rolls in sauté pan and then plate. Spoon chimichurri over rolls and garnish with pickled red onion.

1 kg Flatiron Steak (spezieller Schnitt aus der Schulter)
120 ml Bier
1 rote Zwiebel (in Ringen)
1/2 Bund Cilantro (chinesisches Koriandergrün)
1 Jalapeno-Pfefferschote in Streifen
Prise gemahlenes Kumin
2 EL Huitlacoche (teure Pilzspezialität; Mais-Trüffel, in Dosen)
180 g Cotija-Käse (Mischung aus Feta-Käse und Parmesan)

Die ersten sieben Zutaten mischen und mindestens zwei Stunden marinieren. Das Steak aus der Marinade nehmen. Eine Pfanne erhitzen und die Zwiebelmarinade darin sautieren. Das Steak in ein Zentimeter dicke Scheiben zerteilen. Die Zwiebel und den Käse darin einwickeln, jede Roulade halbieren und feststecken. Etwas Öl in der Pfanne erhitzen und die gewürzten Rouladen rasch anbraten. Dazu passt Chimichurri-Sauce und eingelegte rote Zwiebeln.

1 kg de steak Flatiron (coupe spéciale de l'épaule)
120 ml de bière
1 d'oignon rouge (en anneaux)
1/2 botte de cilantro (feuilles de coriandre chinois)
1 piment jalapeño en lamelles
Une pincée de cumin moulu
2 c. à soupe de huitlacoche (spécialité de champignon ; truffes au maïs, en boite)
180 g de fromage Cotija (mélange de fromage Feta et de parmesan)

Mélanger les sept premiers ingrédients et faire macérer au moins deux heures. Retirer le steak de la marinade. Faire chauffer une poêle et y sauter la marinade d'oignon. Découper le steak en plaques d'un centimètre d'épaisseur. Envelopper avec les oignons et le fromage, couper en deux chaque paupiette et fixer avec une broche. Faire chauffer un peu d'huile dans la poêle et y faire rôtir brièvement la paupiette assaisonnée. Ce plat est délicieux avec de la sauce chimichurri et des oignons rouges confits.

1 kg de bistec Flatiron (corte especial de la paletilla)
120 ml de cerveza
1 cebolla roja (cortada en aros)
1/2 manojo de cilantro (hojas de cilantro chino)
1 pimiento jalapeño cortado en tiras
Una pizca de comino molido
2 cucharadas de huitlacoche (una especialidad cara a base de setas; trufa de maíz en lata)
180 g de queso cotija (mezcla de queso feta y parmesano)

Mezclar los primeros siete ingredientes y dejar marinar durante al menos dos horas. Sacar el bistec del escabeche. Poner una sartén al fuego y saltear en ella el escabeche de cebollas. Cortar el bistec en rodajas de un centimetro de espesor. Envolver en ellas la cebolla y el queso; cortar por la mitad cada rollo y fijarlos para que no se abran. Calentar algo de aceite en la sartén y freír a fuego fuerte los bistecs sazonados y enrollados. Servir con chimichurri y cebollas rojas en vinagre.

1 kg di bistecca flatiron (taglio speciale dalla spalla)
120 ml di birra
1 cipolla rossa (tagliata a rondelle)
1/2 mazzo di cilantro (foglie di coriandolo cinese)
1 peperoncino jalapeno tagliato a strisce
Un pizzico di cumino macinato
2 cucchiai di huitlacoche (specialità di funghi costosa; tartufo di mais, in scatola)
180 g di formaggio cotica (un misto tra formaggio feta e parmigiano)

Mescolate i primi sette ingredienti e fate marinare le bistecche per almeno due ore. Togliete le bistecche dalla marinata. Scaldate una padella e fatevi saltare la marinata di cipolle. Tagliate le bistecche a fettine di circa uno centimetro di spessore. Distribuite le cipolle ed il formaggio sulle bistecche e rotolatele, tagliate ogni involtino a metà e fissatelo con stecchini. Scaldate poco olio in padella e fate rosolare gli involtini aromatizzati velocemente. Si abbinano bene il chimichurri e le cipolle rosse marinate.

Norman's

Design: Michael Guthrie, www.mgandco.com
Chef: Norman Van Aken

8570 Sunset Blvd / La Cienega Boulevard | West Hollywood, CA 90069
Phone: +1 310 657 2400
www.normans.com
Opening hours: Tue–Thu 6 pm to 10 pm, Fri–Sat 6 pm to 10:30 pm,
Sun–Mon closed, Lounge & Bar 5:30 pm to close
Average price: $ 35
Cuisine: Caribbean, Latin American, Pan-Asian & Pacific Rim

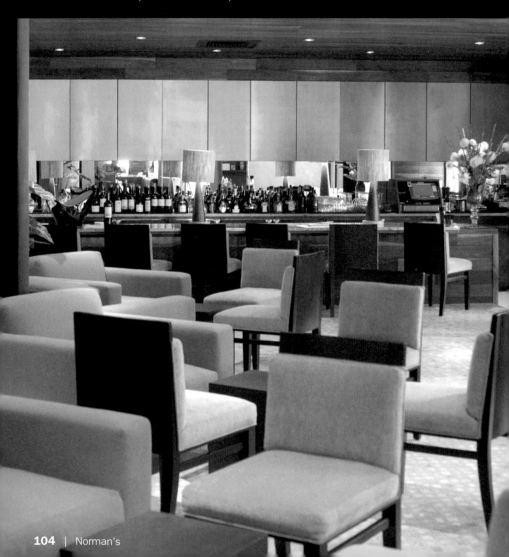

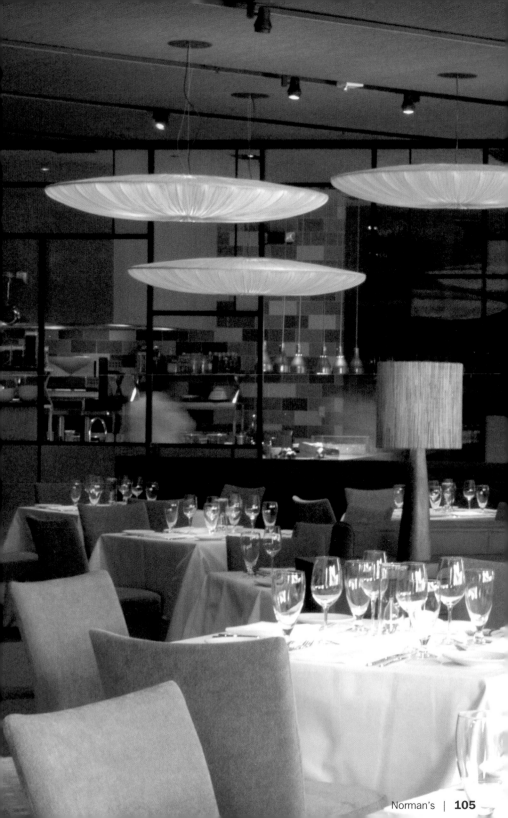

"Nochebuena"

Roast Pork Havana

„Nochebuena" Schweinekeule Havana

Cuisse de porc Havana « Nochebuena »

Pierna de cerdo La Habana para "Nochebuena"

Stinco di maiale "Nochebuena" alla Havana

9 lbs fresh bone-in ham, butt or shank half, skin removed
3 large cloves of garlic, sliced thin
90 ml each orange and lemon juice
1/4 cup lime juice
3/4 cup olive oil
2 bayleaves, broken
1 tbsp ground black pepper
1 tbsp ground cumin seeds

Whisk together the juices, oil, spices, and sliced garlic. Now put the ham in a bag large enough to hold it and pour in the marinade. Tie up the bag. Let this marinade for at least two and up to four days.
Preheat an oven to 325 °F.
Take the pork out of the marinade and put it into a Dutch oven or roasting pan, fat side up. Cover and cook for one and a half hours more. Turn the meat one last time and cook one more hour. Mow the meat should be almost falling off the bone. If it is not, it needs more time covered in the oven. Turn up the heat to 375 °F and cook uncovered a half hour to brown.
Now remove the roast to a cutting board and allow to rest a few moments. Pull apart the pork with two big forks, degrease the remaining drippings from the roasting pan and pour the jus over it.
Serve this with basic white rice, Maduro Plaintains and pickled red onions.

4 kg Schweinekeule mit Knochen ohne Schwarte oder Hinterbacke vom Schwein
3 große Knoblauchzehen in dünnen Scheiben
je 90 ml Orangen- und Zitronensaft
60 ml Limettensaft
180 ml Olivenöl
2 Lorbeerblätter zerstoßen
1 EL gemahlener schwarzer Pfeffer
1 EL gemahlenes Kumin (Kreuzkümmel)

Saft, Öl, Gewürze und Knoblauch mischen. Die Keule in einen ausreichend großen Folienbeutel geben und die Marinade hinzugeben. Den Beutel verschließen. Die Keule mindestens für zwei bis vier Tage marinieren.
Den Ofen auf 180 °C vorheizen.
Die Keule aus der Marinade nehmen und in eine Fleischpfanne mit Deckel geben. Zugedeckt für eineinhalb Stunden garen. Nochmals drehen und eine weitere Stunde garen. Nun sollte sich das Fleisch vom Knochen lösen. Falls nicht, abgedeckt etwas weiter garen.
Nun die Temperatur des Ofens auf 200 °C erhöhen und das Fleisch ohne Deckel eine halbe Stunde bräunen lassen. Das Fleisch auf einem Schneidebrett einige Minuten ruhen lassen. Mit zwei Gabeln das Fleisch zerteilen, den Bratensaft entfetten und über das Fleisch gießen.
Dazu passen weißer Reis, Maduro Plantains (bananenartiges Gemüse) und eingelegte rote Zwiebeln.

4 kg de cuisse de porc avec l'os sans la couenne ni le jambon
3 grosses gousses d'ail en tranches fines
Respectivement 90 ml de jus d'orange et de jus de citron
60 ml de jus de citron vert
180 ml d'huile d'olive
2 feuilles de laurier concassées
1 c. à soupe de poivre noir moulu
1 c. à soupe de cumin croisé moulu

Mélanger le sel, l'huile, les fines herbes et l'ail. Mettre la cuisse dans un sac en plastique suffisamment grand et y ajouter la marinade. Fermer le sac. Laisser macérer la cuisse au moins deux à quatre jours.
Préchauffer le four à 180 °C.
Retirer la cuisse de la marinade et la mettre dans une poêle à viande avec couvercle. Laisser cuire couvert pendant un heure et demi. Retourner de nouveau et laisser cuire une autre heure. La viande doit maintenant se décoller de l'os. Si ce n'est pas le cas, continuer à cuire en gardant couvert. Augmenter maintenant la température du four à 200 °C et faire saisir la viande sans couvert pendant une demi-heure. Laisser reposer la viande sur une planche à couper pendant quelques minutes. Découper la viande avec deux fourchettes, dégraisser le jus de viande et verser sur la viande.
Nous recommandons avec ce plat du riz blanc, des plantains de Maduro (légume apparenté à la banane) et des oignons rouges confits.

4 kg de pierna de cerdo con hueso y sin corteza o bien una nalga de cerdo
3 dientes de ajo grandes cortados en rodajas finas
90 ml de zumo de naranja y de limón, respectivamente
60 ml de zumo de lima
180 ml de aceite de oliva
2 hojas de laurel machacadas
1 cucharada sopera de pimienta negra molida
1 cucharada sopera de comino

Mezclar el zumo, el aceite, las especias y el ajo. Introducir la pierna en una bolsa de plástico lo suficientemente grande y añadir el escabeche. Cerrar la bolsa. Dejar reposar la pierna de cerdo durante dos a cuatro días en el escabeche.
Precalentar el horno a 180 °C.
Extraer la pierna de cerdo del escabeche y colocar en una sartén de carne provista de tapa. Dejar que se ase durante una y media horas con la sartén tapada. Darle la vuelta y dejar que siga asándose otra hora más. Ahora, la carne debería desprenderse del hueso. Si no es así, volver a tapar la sartén y dejar un poco más de tiempo en el horno.
A continuación, aumentar la temperatura del horno a 200° C, quitar la tapa y dejar que la carne se dore durante media hora más. Dejar reposar la carne sobre una tabla de cortar durante varios minutos. Trocear la carne con ayuda de dos tenedores, retirar la grasa del jugo de la carne y verter encima de la carne.
Servir con arroz, plátanos macho ("plantains") y cebollas rojas en vinagre.

4 kg di stinco di maiale con l'osso, senza cotenne oppure coscia di maiale
3 spicchi grandi di aglio, mondati finemente
90 ml di succo di arance e 90 ml di succo di limone
60 ml succo di limoni verdi
180 ml di olio di oliva
2 foglie di alloro spolverizzate grossolanamente
1 cucchiaio di pepe nero macinato
1 cucchiaio di comino romano

Mescolate il succo e l'olio con le spezie e l'aglio. Inserite lo stinco di maiale in un sacco di plastica sufficientemente grande ed aggiungete la marinata. Chiudete il sacchetto. Fate marinare lo stinco per almeno due a quattro giorni.
Preriscaldate il forno a 180 °C.
Togliete lo stinco dalla marinata ed inseritelo in una casseruola da carne con coperchio. Fate cuocere per un'e mezza ora coperchiandola. Girate lo stinco nuovamente e continuate la cottura per un'altra oretta. Ora la carne dovrebbe staccarsi dall'osso. Se non si staccasse, continuate la cottura per un po' di tempo, coperchiando. Ora aumentate la temperatura del forno a 200 °C e fate dorare la carne senza coperchio per una mezz'ora. Togliete la carne e fatela riposare per alcuni minuti su un tagliere. Dividete la carne con l'aiuto di due forchette, sgrassate il sughetto di cottura e nappate la carne con il sughetto.
Si abbinano bene il riso bianco, i maduro plaintains (una verdura simile a banane) e cipolle rosse marinate.

Oliver Café & Lounge

Design: Dodd Mitchell | Owner: Mario Oliver
Chef: James R. Legge

9601 Wilshire Blvd / Camden | Beverly Hills, CA 90210
Phone: +1 310 888 8160
www.olivercafe.com
Opening hours: Mon–Sun breakfast 7 am to 11 pm, lunch 11 am to 3 pm,
"chilled-out hour" 4 pm to 7 pm, Sat–Sun breakfast is served till 2 pm
Average price: $ 25
Cuisine: Traditional American, health food

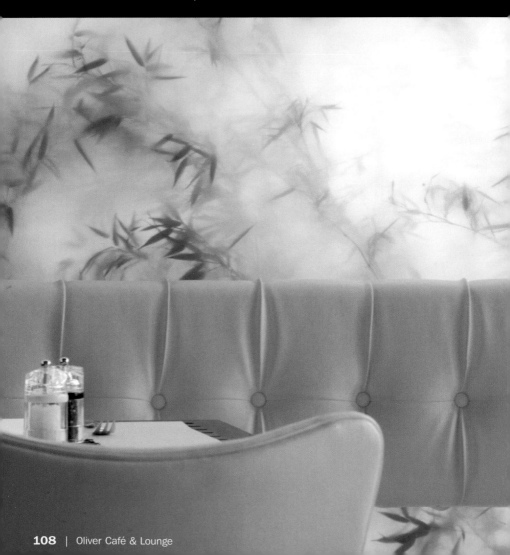

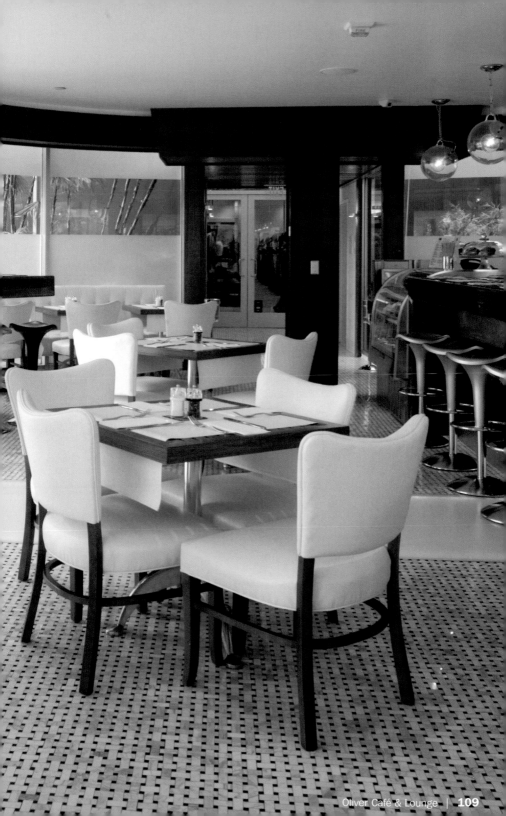

Ceasar Salad

Salat „Caesar"
Salade « César »
Ensalada "César"
Insalata "Caesar"

1 head of romanesco

For the dressing:
1 tsp chopped garlic
2 egg yolks
4 oz grated parmesan
1/8 cup balsamic vinegar
1/4 cup red wine vinegar
2 tsp lemon juice
2 tsp Dijon mustard
1/2 cup anchovy filet
1/2 tsp salt
1/4 tsp pepper
1/2 cup pure olive oil

Combine all the ingredients for the dressing in a blender and blend until smooth.

Clean the Romanesco and pull off the sprouts. Then wash it and cook in slightly salted water until it is al dente. Let it cool off and carefully mix the cauliflower sprouts with the dressing. Very young Romanesco can also be used raw.

Garnish the salad with tomatos, olives, cold poached shrimps, turkey, slices of chicken breast and tuna.

1 Kopf Romanesco

Für das Dressing:
1 TL gehackter Knoblauch
2 Eigelb
120 g geriebener Parmesan
30 ml Balsamico Essig
60 ml Rotweinessig
2 TL Zitronensaft
2 TL Dijon Senf
50 g Anchovis
1/2 TL Salz
1/4 TL Pfeffer
125 ml Ölivenöl

Alle Zutaten für das Dressing in einem Mixer geben und zu einer glatten Masse pürieren.

Den Romanesco putzen und in kleine Röschen zerpflücken. Anschließend waschen und in leicht gesalztem Wasser bisfest garen. Abkühlen lassen und die Kohlröschen vorsichtig mit dem Dressing mischen.
Sehr junger Romanesco kann auch roh verarbeitet werden.

Den Salat nach Wahl mit Tomaten, Oliven, gekochten Shrimps, Truthahnschinken, Hähnchenbruststreifen und Thunfisch garnieren.

1 tête d'chou romanesco

Pour la sauce :
1 c. à café d'ail haché
2 jaunes d'oeuf
120 g de parmesan râpé
30 ml de vinaigre de balsamico
60 ml de vinaigre de vin rouge
2 c. à café de jus de citron
2 c. à café de moutarde de Dijon
50 g d'anchois
1/2 c. à café de sel
1/4 c. à café de poivre
125 ml d'huile d'olive

Versez tous les ingrédients pour la sauce dans un mixeur et réduisez en purée jusqu'à obtention d'une pâte lisse.

Lavez le romanesco et découpez-le en petits bouquets. Lavez-le ensuite puis faites-le cuire dans de l'eau légèrement salée (il doit rester croquant). Laissez refroidir puis incorporez doucement les bouquets de chou à la sauce.
S'il s'agit d'un très jeune romanesco, vous pouvez l'incorporer cru.

Garnir au choix la salade de tomates, d'olives, de crevettes cuites, de jambon de dindon, de poitrine de poulet en lamelles et de thon.

1 cabeza de romanesco

Para la salsa:
1 cucharita de ajo picado
2 yemas de huevo
120 g de parmesano rallado
30 ml de vinagre balsámico
60 ml de vinagre de vino tinto
2 cucharaditas de zumo de limón
2 cucharaditas de mostaza de Dijon
50 g de anchoas
1/2 cucharita de sal
1/4 cucharita de pimienta
125 ml de aceite de oliva

Poner todos los ingredientes para la salsa en una batidora y hacer con ellos un puré fino.

Desbrozar el romanesco y hacer de él pequeñas rosetas. Lavar seguidamente y cocer en agua salada al dente. Dejar enfriar y mezclar las rosetas de col cuidadosamente con el aderezo. El romanesco tempranero puede procesarse también crudo.

Aderezar la ensalada al gusto con tomates, aceitunas, gambas cocidas, jamón de pavo, tiras de pechuga de pollo y atún.

1 cavolo romanesco

Per la salsa:
1 cucchiaino di aglio tritato
2 tuorli
120 g di parmigiano grattugiato
30 ml di aceto balsamico
60 ml di aceto di vino rosso
2 cucchiaini di succo di limone
2 cucchiaini di senape francese
50 g di filetti di acciughe
1/2 cucchiaino di sale
1/4 cucchiaino di pepe
125 ml di olio di oliva

Mettete tutti gli ingredienti per la salsa nel frullatore e frullate finemente tutto fino ad ottenere una crema omogenea.

Pulite il cavolo e dividetelo a pezzetti. Ora lavate i pezzetti e fateli cuocere al dente, in acqua leggermente salata. Fateli raffreddare e mescolate delicatamente con la salsa.
Il cavolo romanesco molto giovane può anche essere lavorato allo stato crudo.

Guarnite l'insalata a scelta con pomodori, olive, scampi bolliti, prosciutto di tacchino, petto di pollo tagliato a strisce e tonno.

Pho Café

Design: Escher GuneWardena Architecture, www.egarch.net
Chef: Thuy Dam

2841 W Sunset Blvd | Los Angeles, CA 90026
Phone: +1 213 413 0888
Opening hours: Every day 11 am to 12 midnight
Average price: up to $ 6.75
Cuisine: Vietnamese home cooking

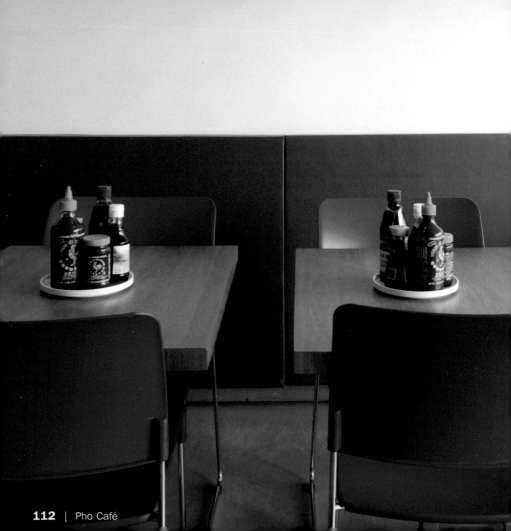

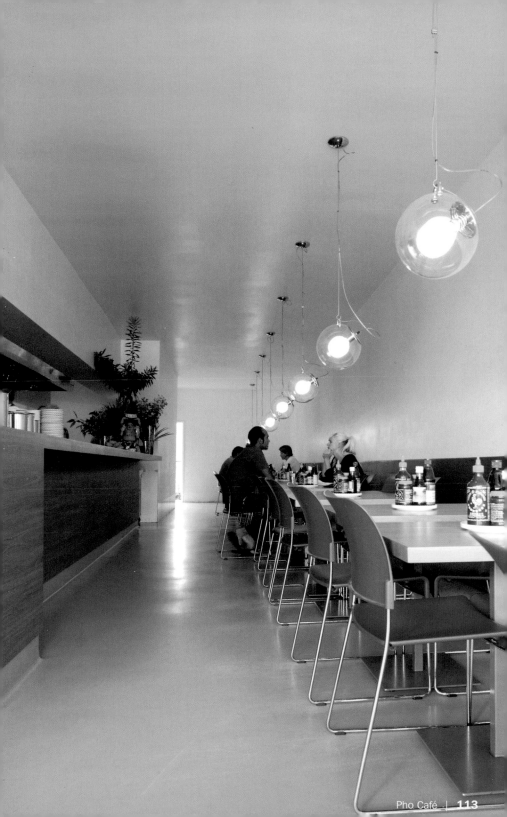

Vietnamese Crêpe

with Lemongrass Steak and Shrimps

Vietnamesischer Crêpe
mit Zitronengrassteak und Shrimps

Crêpes vietnamiennes avec steak avec
steak au thym citronné et aux crevettes

Crepe vietnamita con bistec a la hierba
de limón y gambas

Crêpe vietnamita con bistecca al
lemongrass e scampi

12 oz crêpe batter
2 lbs marinated beef
1 lb shrimp, cooked and cut in half lenghtwise
4 cups bean sprouts, rinsed and drained
2 cups shiitake mushrooms, thinly sliced
1 cup mungo beans, cooked

Crêpe Batter:
12 oz rice starch
1 tsp dry coconut powder
1 tsp curry powder
1 tsp curkuma
2 1/3 cups water
Use only Asian rice starch (bot gao te / bot te tinh
khiet). Combine all of the above in a large bowl
and stir until very thin and slurry.

Marinated Beef:
1 lb tenderloin beef
2 stalks of lemongrass
5 crushed garlic gloves

2 tsp fish sauce
1 tsp sugar
1 tsp ground pepper
1 tsp sesame oil
1 tsp vegetable oil
2 tsp sesame seeds
Cut the beef crosswise against the grain into very
thin slices. Discard the outer leafs and upper half
of the lemongrass stalks and chop finely.
Combine slices of beef with lemongrass. Add fish
sauce, garlic, sugar, pepper, sesame oil, canola
oil and sesame seeds. Set aside to marinate for
30 minutes.

Makes about 12 crêpes. Now heat some vegeta-
ble oil and add marinated beef. Cook until tender
and add vegetables. When done, combine with
the shrimp to heat them up. Put beef-veggie-mix
on crêpe, fold and roll up.
Serve with peanut sauce.

340 g Crêpeteig
900 g mariniertes Rindfleisch
450 g halbierte, geputzte, gekochte Shrimps
400 g Sojasprossen
200 g Shitakepilze
100 g Mungobohnensprossen

Crêpeteig:
340 g Reismehl
1 TL Kokosnusspulver
1 TL Curry
1 TL Kurkuma
600 ml Wasser
Alle Zutaten mischen, der Teig muss dünn und
wässrig sein. Nur Asia-Reismehl (bot gao te / bot
tinh khiet) verwenden.

Mariniertes Rindfleisch:
450 g Rinderfilet
2 Stängel Zitronengras
5 zerdrückte Knoblauchzehen

2 TL Fischsauce
1 TL Zucker
1 TL Pfeffer
1 TL Sesamöl
1 TL Sonnenblumenöl
2 TL Sesam
Das Rind gegen die Maserung in dünne Scheiben
schneiden. Die äußeren Blätter und den oberen
Teil des Zitronengrases entfernen und kleinhacken.
Die Rinderfiletscheiben mit dem Zitronengras
mischen und die restlichen Zutaten zugeben.
Beiseite stellen und 30 Minuten marinieren.

Dünne Crêpe ausbacken und warmstellen. Das
Rindfleisch in einer Pfanne anbraten und das
Gemüse zugeben. Zum Schluss die Shrimps mit
erwärmen, auf den Crêpe verteilen und einrollen.
Dazu Erdnussbuttersauce servieren.

340 g de pâte à crêpe
900 g de viande de bœuf marinée
450 g de crevettes coupées en deux, nettoyées et cuites
400 g de germes de soja
200 g de champignons Shitake
100 g de haricots mungo

Pâte à crêpe :
340 g de farine de riz
1 c. à café de poudre de noix de coco
1 c. à café de curry
1 c. à café de curcuma
600 ml d'eau
Mélanger tous les ingrédients, la pâte doit être fine et liquide. Utiliser seulement de la farine de riz asiatique (bot gao te/bot tinh khiet).

Viande de bœuf marinée :
450 g de filet de bœuf
2 brins de thym citronné

5 gousses d'ail écrasées
2 c. à café de sauce au poisson
1 c. à café de sucre
1 c. à café de poivre
1 c. à café d'huile de sésame
1 c. à café d'huile de tournesol
2 c. à café de sésame
Couper le bœuf en tranches fines contre la veinure. Retirer les feuilles extérieures et la partie supérieure du thym citronné et hacher finement. Mélanger les tranches de filet de bœuf avec le thym citronné et ajouter le reste des ingrédients. Mettre de côté et laisser macérer 30 minutes.

Faire des crêpes fines et mettre au chaud. Faire rôtir la viande de bœuf dans une poêle et ajouter les légumes. Pour finir, réchauffer les crevettes avec le mélange, répartir sur la crêpe et enrouler. Servir avec de la sauce au beurre de cacahuète.

340 g masa de crepe
900 g carne de vaca marinada
450 g de gambas cocidas partidas por la mitad
400 g brotes de soja
200 g setas Shitake
100 g brotes de judías mungo

Masa de crepe:
340 g de harina de arroz
1 cucharita de coco en polvo
1 cucharita de curry
1 cucharita de cúrcuma
600 ml de agua
Mezclar todos los ingredientes. La masa debe ser líquida y acuosa. Uitliar sólo harina de arroz asiática (bot gao te / bot tinh khiet).

Carne de vaca marinada:
450 g de filete de vaca
2 tallos de hierba de limón
5 dientes de ajo machacados

2 cucharitas de salsa de pescado
1 cucharita de azúcar
1 cucharita de pimienta
1 cucharita de aceite de sésamo
1 cucharita de aceite de girasol
2 cucharitas de semillas de sésamo
Cortar la carne de vaca en tiras finas en sentido contrario a las vetas. Retirar las hojas exteriores y la parte superior de la hierba de limón y trocear finamente. Mezclar las tiras de carne con la hierba de limón y añadir los demás ingredientes. Colocar a un lado y dejar marinar durante 30 minutos.

Preparar los crepes y mantenerlos calientes. Freír la carne de vaca en una sartén y añadir la verdura. Agregar finalmente las gambas hasta que se calienten. Esparcir encima de los crepes y enrollarlos.
Servir con salsa de manteca de cacahuete.

340 g di impasto da crêpe
900 g carne di manzo marinata
450 g di scampi tagliati a metà, puliti e bolliti
400 g di germogli di soia
200 g di funghi shiitake
100 g di germogli di fagioli mungo

Per l'impasto da crêpe
340 g di farina di riso
1 cucchiaino di polvere di noce di cocco
1 cucchiaino di curry
1 cucchiaino di curcuma
600 ml di acqua
Mescolate tutti gli ingredienti. L'impasto deve essere leggero ed acquoso. Usate esclusivamente la farina di riso asiatica (bot gao te/bot tinh khiet).

Carne di manzo marinata:
450 g di filetto di manzo
2 gambi di lemongrass

5 spicchi di aglio schiacciati
2 cucchiaini di salsa di pesce
1 cucchiaino di zucchero
1 cucchiaino di pepe
1 cucchiaino di olio di sesamo
1 cucchiaino di olio di semi di girasole
2 cucchiaini di sesamo
Tagliate la carne di manzo a fettine sottili e contro il senso della venatura. Togliete le foglie esterne e la parte superiore del lemongrass e tritatelo finemente. Mescolate le fettine di manzo con il lemongrass ed aggiungete gli altri ingredienti. Mettete da parte e fate marinare per 30 minuti.

Fate friggere un crêpe sottile e mettetelo da parte. Fate rosolare la carne di manzo in una padella ed aggiungete la verdura. In fondo aggiungete gli scampi e fateli scaldare, distribuite il tutto sul crêpe e rotolatelo.
Servite con la salsa di burro di arachidi.

R23

Owner: Jakes Oda | Chef: Tatsumi Towita

923 E Second St #109 | Los Angeles, CA 90012
Phone: +1 213 687 7178
www.r23.com
Opening hours: Mon–Fri Lunch 11:30 am to 2 pm,
Mon–Sat Dinner 5:30 pm to 10 pm, closed on Sunday
Average price: $ 45
Cuisine: Japanese, sushi

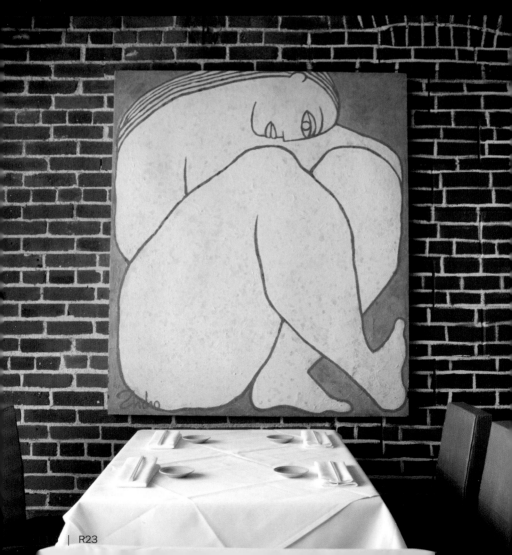

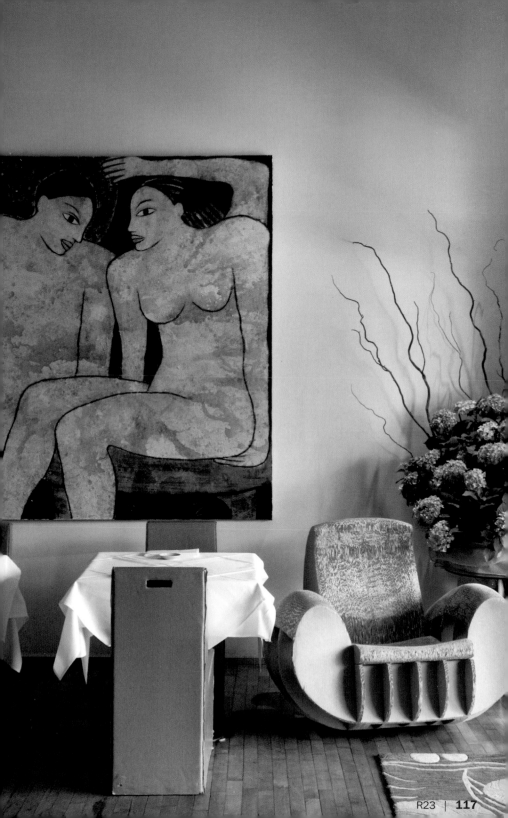

Table 8

Design: Robert Wildasin | Chef: Govind Armstrong
Sous Chef: Andrew Kirschner

7661 Melrose Ave / Spaulding Ave | Los Angeles, CA 90046
Phone: +1 323 782 8258
Opening hours: Sun–Thu 6 pm to 10 pm, Fri–Sat 6 pm to 11 pm,
Lounge: Sun–Thu 5:30 pm to 11 pm, Fri–Sat 5:30 pm to 1 am
Average price: $ 35
Cuisine: American
Special features: Closed private room, outdoor dining, valet parking

Table 8 | **121**

Salt Roasted
Porterhouse

Porterhousesteak mit Salzkruste
Steak chateaubriand en croûte de sel
Bistec Porterhouse con costra de sal
Bistecca alla Porterhouse nella crosta di sale

1 lb salt
2 tsp whole coriander seed
6 bay leaves, crushed
1/2 tsp chile flake
1 tbsp cracked black pepper
1 tsp fennel seed
1 tbsp mustard seed

1 dry-aged porterhouse (2 lbs)
3-4 fresh thyme sprigs

Preheat the oven to 475 °F. Combine all the ingredients for the crust in a bowl and moisten with one eigths of a cup of water. Place the steak in the center of a cast iron pan, lay a few fresh thyme sprigs on the meat and cover with the salt. Place in the oven for 25 minutes for medium rare, then put under the broiler for about one and a half minutes. Allow the steak to rest for about ten minutes. Crack the salt crust using the back of a spoon and remove the remaining salt from the meat. Check for doneness. If necessary, place steak under the grill for a few minutes.

450 g Salz
2 TL Koriandersamen
6 Lorbeerblätter, gemahlen
1/2 TL Chilliblätter, gemahlen
1 EL schwarzer Pfeffer (grob gemahlen)
1 TL Fenchelsamen
1 EL Senfsamen

1 abgehangenes Porterhousesteak (ca. 900 g)
3-4 Thymianzweigen

Den Ofen auf 250 °C vorheizen. Die Zutaten für die Kruste in einer Schüssel vermengen und mit 30 ml Wasser befeuchten. Das Steak auf ein Blech legen und mit einigen Thymianzweigen, sowie der Salzmischung bedecken. Ca. 25 Minuten backen (medium rare), anschließend für eineinhalb Minuten unter den Grill. Danach sollte das Steak für zehn Minuten ruhen. Die Salzkruste mit einem Löffel aufbrechen und das restliche Salz entfernen. Garstufe überprüfen, falls nötig unter dem Grill etwas nachgaren.

450 g de sel
2 c. à café de graines de coriandre
6 feuilles de laurier, moulu
1/2 c. à café de feuilles de chili, moulu
1 c. à soupe de poivre noir (moulu grossier)
1 c. à café de graines de fenouil
1 c. à soupe de graines de moutardes

1 steak chateaubriand maturé (env. 900 g)
3-4 brins de thym

Préchauffer le four à 250 °C. Mélanger les ingrédients pour la croûte dans un saladier et humidifier avec 30 ml d'eau. Déposer le steak sur une plaque de cuisson puis couvrir avec quelques brins de thym et le mélange à base de sel. Faire cuire pendant env. 25 minutes (medium rare), puis durant un et demi minutes sous le grill. Le steak doit ensuite reposer pendant dix minutes. Rompre la croûte de sel avec une cuillère et retirer le reste du sel. Vérifier le degré de cuisson, si nécessaire, cuire encore un peu.

450 g de sal
2 cucharaditas de semillas de cilantro
6 hojas de laurel, molidas
1/2 cucharadita de hojas de chili, molidas
1 cucharada de pimienta negra (molida gruesa)
1 cucharadita de semillas de hinojo
1 cucharada de semillas de mostaza

1 bistec Porterhouse manido (aprox. 900 g)
3-4 ramitas de tomillo

Precalentar el horno a 250 °C. Mezclar los ingredientes para la costra en un recipiente y humedecer con 30 ml de agua. Colocar el bistec sobre una bandeja de horno y cubrir con algunas ramitas de tomillo y la mezcla de sal. Asar unos 25 minutos (medium rare) y seguidamente exponer uno y medio minutos al calor de la parrilla. A continuación, dejar reposar el bistec durante diez minutos. Abrir la costra de sal con una cuchara y eliminar el resto de sal. Comprobar el estado de preparación y, si fuera necesario, volver a colocar en el horno para que quede más hecho.

450 g di sale
2 cucchiaini di semi di coriandolo
6 foglie di alloro, macinate
1/2 cucchiaino di peperoncino macinato
1 cucchiaio di pepe nero (macinato grezzamente)
1 cucchiaino di semi di finocchio
1 cucchiaio di semi della pianta di senape

1 bistecca alla Porterhouse frollata (ca. 900 g)
3-4 rametti di timo

Preriscaldate il forno a 250 °C. Mescolate gli ingredienti per la crosta di sale in una scodella ed inumidite con 30 ml di acqua. Adagiate la bistecca su una teglia e copritela con alcuni rametti di timo e con il sale condito. Fate cuocere al forno per circa 25 minuti (medium rare), dopodiché per uno et mezzo minuto sotto la griglia. Dopo dovreste far riposare la bistecca per dieci minuti. Rompete la crosta di sale con un cucchiaio ed eliminate i resti di sale. Verificate il grado di cottura e, se necessario, fatela terminare.

Table 8 | **123**

Tantra

Design: Sat Garg, Akar Studios | Owner: Navraj Singh
Chef: Sanjay Kumar

3705 W Sunset Blvd / Griffith Park Blvd | Los Angeles, CA 90026
Phone: +1 323 663 8268
www.tantrasunset.com
Opening hours: Tue–Sun 5 pm to 12 midnight
Average price: $ 25
Cuisine: Indian
Special features: Late night dining, lounge, valet parking

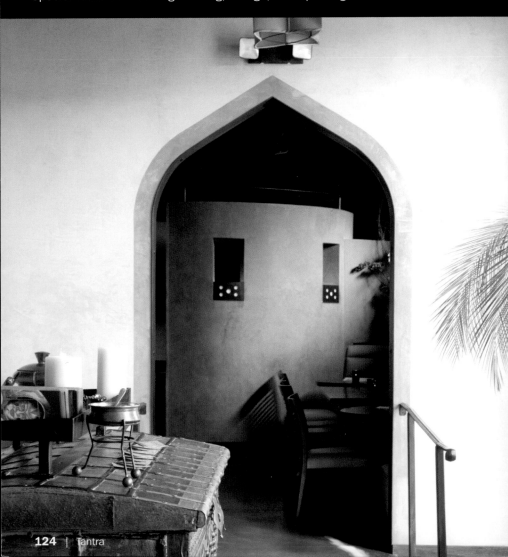

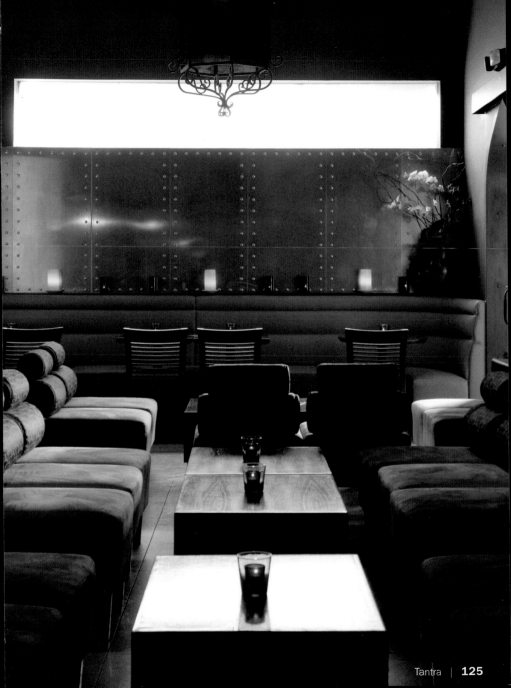

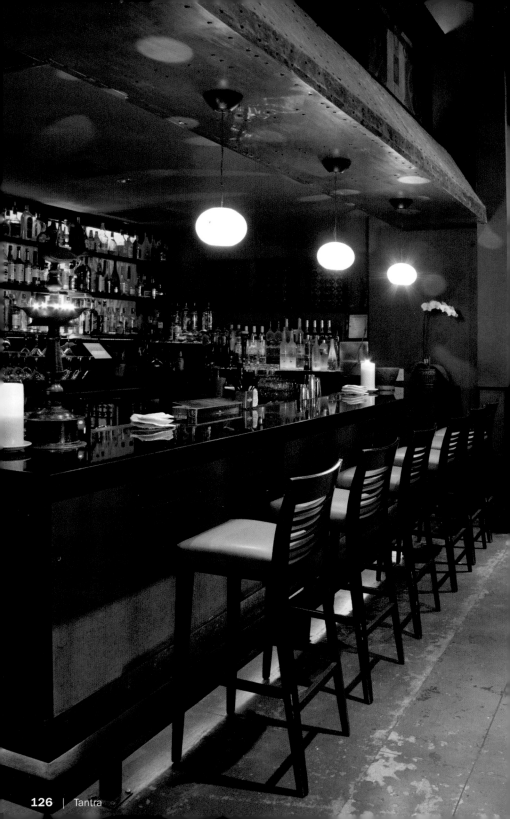

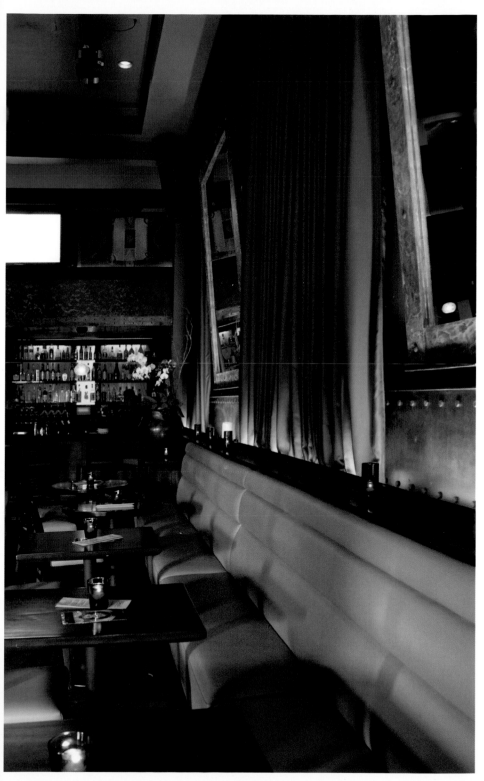

White Lotus

Design: Chris Breed | Chef: Andrew Pastore

1743 N Cahuenga Blvd | Hollywood, CA 90028
Phone: +1 323 463 0060
www.whitelotushollywood.com
Opening hours: Tue–Sat 6 pm to 10:30 pm, Club Tue–Sat 9 pm to 2 am
Average price: $ 35
Cuisine: Asian, Chinese, Dim Sum, sushi
Special features: Late night dining, celeb hangout, dancing, outdoor dining, valet parking

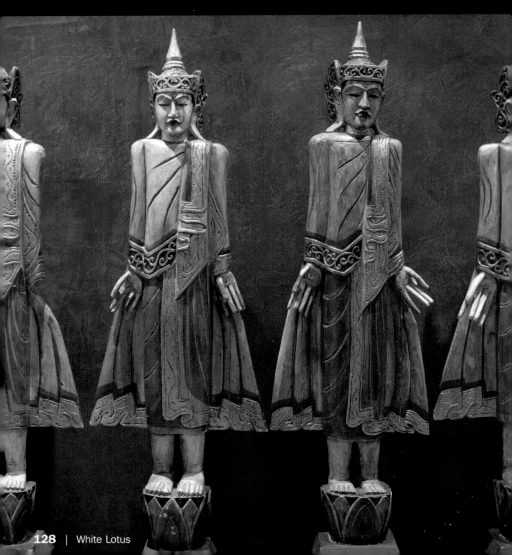

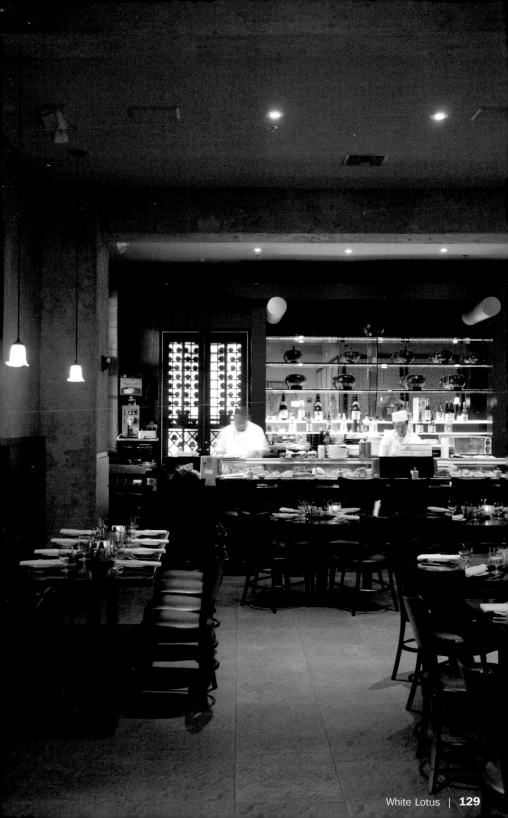

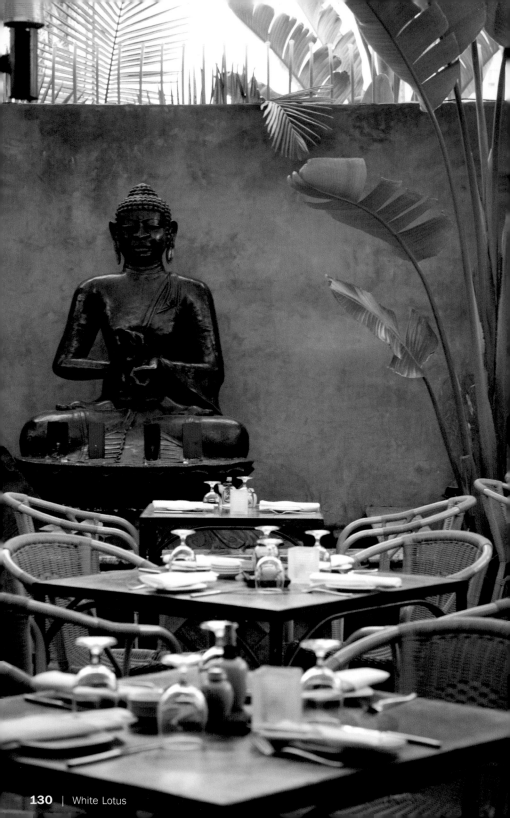

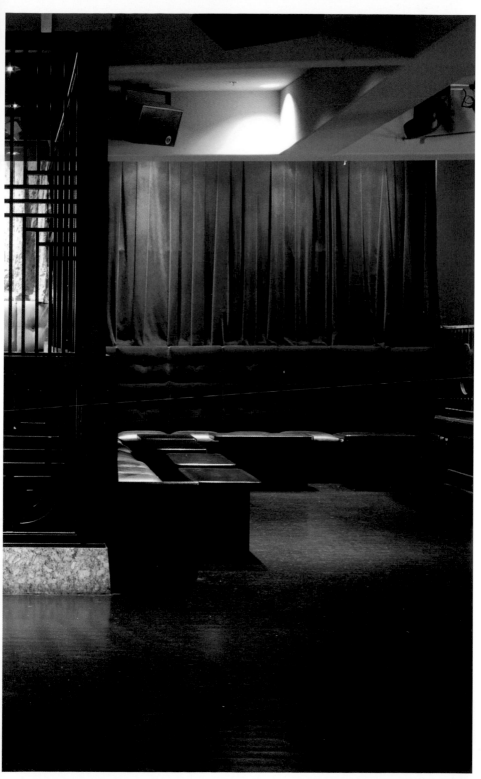

Sesame Crusted
Alaskan Halibut
with Coconut Scented Sticky Rice, Baby Bok Choy & Thai Glaze

Alaska-Heilbut mit Sesamkruste an Kokos-nussreis, Baby Bok Choy und Thaiglasur

Flétan d'Alaska et sa croûte de sésame sur riz à la noix de coco, mini bok choy et glaçage thaïlandais

Rodaballo de Alasca recubierto de sésamo con arroz al coco, Bok Choy tierno y cobertura tailandesa

Ippoglosso dell'Alaska con crosta di sesamo e riso alla noce di cocco, baby bok choy e glassatura alla tailandese

2 7 oz portions fresh Alaskan halibut
1 cup sesame
2 baby bok choy—julienne
1/4 cup sweet shredded coconut
4 lime leaves—chopped
2 tbsp vegetable oil
2 cups instant rice—cooked
For the sauce:
2 cups water
8 oz vinegar-rice wine
8 oz sugar
4 oz soy sauce
4 oz fish sauce
2 oz tomato paste
2 oz cornstarch—dissolved in water
1/2 oz ginger—minced
2 oz vegetable oil
1/2 oz garlic—minced
2 oz cilantro—chopped (Chinese parsley)
1 oz coconut milk
Sautée garlic and ginger in vegetable oil until light brown. Stir in tomato paste, then add water, vinegar, and sugar and bring to boil. Reduce to a simmer, stir in cornstarch and simmer for three minutes or until sauce is clear. Remove from heat, add cilantro and reserve for plating.
Fish: Heat medium sauté pan on high heat for one minute. Add vegetable oil and heat an additional minute. Coat halibut with sesame mix on one side and place in hot pan seed side down. Let seeds brown approx. one minute and turn fish over. Place pan in 450 °F oven for approx. six minutes or until desired doneness.
Vegetables: Heat medium sauté pan on high heat and add vegetable oil. Add sliced garlic and slightly brown. Add bok choy and stir until desired doneness. Reserve for plating.
Add coconut and lime leaves to cook rice and stir in. Add butter and season to taste. Place rice in center of plate. Place desired amount of bok choy on top of rice mixture. Place halibut on top of vegetables. Pour Thai glaze on top of plate.

2 Portionen Alaska-Heilbutt (ca. 180 g)
150 g Sesam
2 Baby Bok Choy (chinesischer Kohl) in Streifen
40 g Kokosraspel
4 Limonenblätter
2 EL Öl
300 g gekochter Reis
Für die Sauce:
500 ml Wasser
250 ml Reisweinessig
220 g Zucker
120 ml Sojasauce
120 ml Fischsauce
60 g Tomatenmark
60 g Speisestärke in Wasser aufgelöst
15 g gehackter Ingwer
2 EL Pflanzenöl
15 g gehackter Knoblauch
60 g Cilantro, gehackt (chinesischer Koriander)
30 ml Kokosnussmilch
Knoblauch und Ingwer in dem Öl bräunen, Tomatenmark unterrühren, mit Wasser, Essig und Zucker ablöschen und zum Kochen bringen. Die Speisestärke unterrühren und andicken lassen. Vom Feuer nehmen und mit dem Cilantro abschmecken.
Fisch: Ofen (230 °C) und Pfanne (backofengeeignet) vorheizen. Den Fisch auf einer Seite in Sesam wälzen und Öl in die Pfanne geben. Den Fisch auf der Sesamseite in die Pfanne geben und ca. eine Minute anbraten, dann umdrehen und die Pfanne in den Ofen schieben. Garzeit ca. sechs Minuten. Warmstellen.
Gemüse: Pfanne erhitzen und Öl hineingeben. Den Knoblauch kurz anschwitzen und das Bok Choy hinzufügen. Bissfest garen und abschmecken. Warmstellen.
Reis, Butter, Kokosraspel und Limonenblätter mischen, abschmecken und warmstellen.
Den Reis in der Mitte des Tellers anrichten. Das Gemüse auf den Reis geben und den Fisch darauf legen. Mit der Sauce vollenden.

2 portion de flétan d'Alaska (environ 180 g)
150 g Sésam
2 mini bok choys (choux chinois) en lamelles
40 g de copeaux de noix de coco
4 feuilles de citron vert
2 c. à soupe d'huile
300 g de riz cuit
Pour la sauce :
500 ml d'eau
250 ml de vinaigre de vin de riz
220 g de sucre
120 ml de sauce au soja
120 ml de sauce au poisson
60 g de purée de tomate
60 g d'amidon dissous dans l'eau
15 g de gingembre haché
2 c. à soupe d'huile
15 g d'ail haché
60 g de cilantro haché (coriandre chinois)
30 ml de lait de coco
Faire brunir l'ail et le gingembre dans l'huile, ajouter

la purée de tomate, arroser avec de l'eau, du vinaigre et du sucre et porter à ébullition. Mélanger au tout l'amidon et laisser épaissir. Retirer du feu et assaisonner avec le cilantro.
Poisson : préchauffer le four (230 °C) et la poêle (apte à la cuisson au four). Rouler le poisson d'un côté dans le sésame et verser de l'huile dans la poêle. Déposer le poisson du côté du sésame dans la poêle, faire cuire pendant environ un minute puis retourner et mettre la poêle dans le four. Temps de cuisson : env. six minutes. Mettre au chaud.
Légumes : faire chauffer la poêle et ajouter de l'huile. Faire blondir l'ail brièvement et y ajouter le bok choy. Faire cuire et assaisonner jusqu'à ce que le tout soit agréable au goût et assaisonner. Mettre au chaud.
Mélanger le riz, le beurre, les copeaux de noix de coco et les feuilles de citron vert, assaisonner et mettre au chaud. Disposer le riz dans le milieu de l'assiette. Mettre les légumes sur le riz et y déposer le poisson. Achever la présentation avec la sauce.

2 porciones de rodaballo de Alasca (aprox. 180 g)
150 g sésamo
2 bok choy tiernos (col china) en rodajas
40 g de coco rallado
4 hojas de lima
2 cucharadas de aceite
300 g de arroz cocido
Para la salsa:
500 ml de agua
250 ml de vinagre de vino de arroz
220 g de azúcar
120 ml de salsa de soja
120 ml de salsa de pescado
60 g de concentrado de tomate
60 g de almidón disuelto en agua
15 g de jenjibre picado
2 cucharadas de aceite
15 g de ajo picado
60 g de cilantro, picado (cilantro chino)
30 ml de leche de coco
Dorar el ajo y el jenjibre en el aceite, agregar el

concentrado de tomate, rebajar con agua, vinagre y azúcar, y esperar hasta que hierva. Añadir el almidón, mezclar y dar vueltas hasta que se espese. Retirar del fuego y sazonar con el cilantro.
Pescado: Precalentar el horno (230 °C) y la sartén (resistente al horno). Cubrir el pescado por un lado con semillas de sésamo y poner aceite en la sartén. Colocar el pescado en la sartén por el lado recubierto de sésamo y freír aprox. un minuto. A continuación, darle la vuelta y colocar la sartén en el horno. Tiempo de preparación: aprox. seis minutos. Mantener caliente.
Verdura: Poner la sartén al fuego y agregar el aceite. Freír brevemente el ajo hasta que se dore y añadir el bok choy. Freír "al dente" y sazonar. Mantener caliente.
Mezclar el arroz, la mantequilla, el coco rallado y las hojas de lima, sazonar y mantener caliente. Aderezar el arroz en el centro del plato. Colocar la verdura encima del arroz y encima de ésta, el pescado. Completar con la salsa.

2 porzioni di ippoglosso dell'Alaska (ca. 180 g)
150 g sesamo
2 baby bok choy (cavolo cinese) tagliato a strisce
40 g di fiocchi disidratati di noce di cocco
4 foglie di limoni verdi
2 cucchiai di olio
300 g di riso bollito
Per la salsa:
500 ml di acqua
250 ml aceto di vino di riso
220 g di zucchero
120 ml di salsa di soia
120 ml di salsa di pesce
60 g concentrato di pomodoro
60 g di fecola sciolta in acqua
15 g di zenzero tritato
2 cucchiai di olio
15 g di aglio tritato
60 g di cilantro tritato (coriandolo cinese)
30 ml di latte di noce di cocco
Fate appassire nell'olio l'aglio insieme allo zenzero,

aggiungete il concentrato di pomodoro, deglassate con l'acqua, l'aceto e lo zucchero e portate ad ebollizione. Ora unitevi la fecola e fate ispessire la salsa. Toglietela dal fuoco ed aggiustate di cilantro.
Per il pesce: preriscaldate il forno e la padella (adatta da forno) a 230 °C. Girate il pesce da una parte nel sesamo e versate l'olio in padella. Disponete in padella il pesce dalla parte coperta di sesamo e fatelo rosolare per circa uno minuto, poi giratelo ed inserite la padella nuovamente nel forno. Tempo di cottura circa sei minuti. Tenetelo al caldo.
Per la verdura: scaldate la padella e versatevi l'olio. Fate appassire brevemente l'aglio ed aggiungete il bok choy. Fatelo cuocere al dente ed aggiustate. Tenetelo al caldo. Mescolate il riso, il burro, i fiocchi di noce di cocco disidratati e le foglie di limoni verdi, aggiustate e tenete il tutto al caldo. Distribuite il riso al centro del piatto. Adagiate la verdura sul riso ed appoggiate il pesce sopra. Completate con la salsa.

Bel Air

Beverly Hil

13

2

10 Santa Monica

19

405

4 Venice

90

1

International
Airport

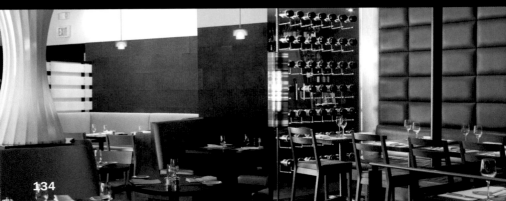

134

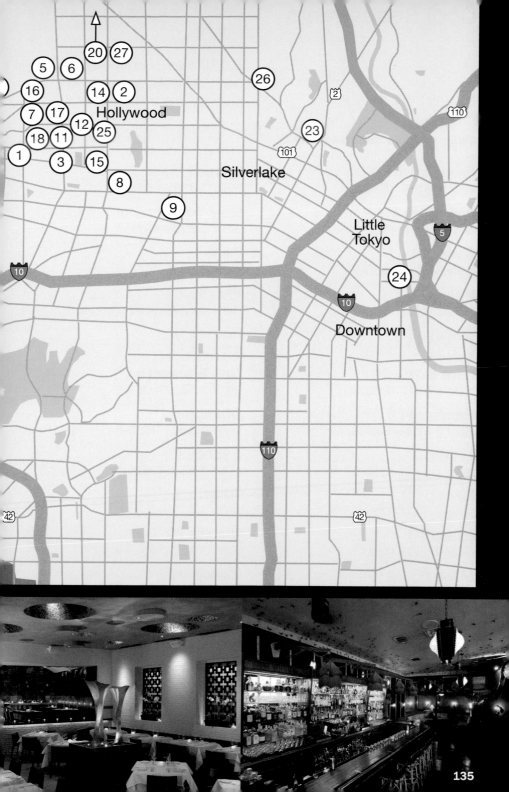

Hollywood

Silverlake

Little
Tokyo

Downtown